Best wishes,
Mary-Jo
Wainwright

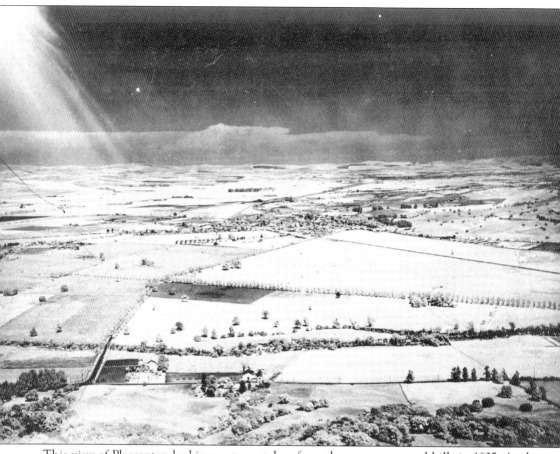

This view of Pleasanton looking east was taken from the western coastal hills in 1935. At the bottom of the image is the end of Bernal Avenue and Foothill Road. This artistic photograph shows the rural nature of Pleasanton. This view would not radically change until the 1960s.

ON THE COVER: Parades on Pleasanton's Main Street have been a tradition from its earliest days. Even today, parades, heritage days, harvest fairs, and farmer's markets bring people downtown to celebrate, relax, and enjoy a sense of community. This 1908 Fourth of July photograph of Pleasanton's past is the most requested historical image from Pleasanton's Museum on Main Street.

Mary-Jo Wainwright and the Museum on Main

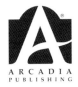

Copyright © 2007 by Mary-Jo Wainwright and the Museum on Main
ISBN 978-0-7385-4761-9

Published by Arcadia Publishing
Charleston SC, Chicago IL, Portsmouth NH, San Francisco CA

Printed in the United States of America

Library of Congress Catalog Card Number: 2007921320

For all general information contact Arcadia Publishing at:
Telephone 843-853-2070
Fax 843-853-0044
E-mail sales@arcadiapublishing.com
For customer service and orders:
Toll-Free 1-888-313-2665

Visit us on the Internet at www.arcadiapublishing.com

*This book is dedicated to the people of Pleasanton, past and present, who painstakingly collected and documented the images and history contained in this book. I also want to express my gratitude to my mentor, Dr. Richard Orsi, who helped me believe I could be a historian and suggested me for this project, and most importantly to my husband, Mark, and my daughter, Samantha, who always supported all my history endeavors no matter their own personal sacrifice.*

# CONTENTS

| | | |
|---|---|---|
| Acknowledgments | | 6 |
| Introduction | | 7 |
| 1. | Conquest and Survival | 9 |
| 2. | A Family Affair | 15 |
| 3. | Pleasanton Grows | 33 |
| 4. | Horses, Hops, and Cows | 53 |
| 5. | Phoebe's Castle | 69 |
| 6. | Progressive Pleasanton | 81 |
| 7. | Fun Times | 93 |
| 8. | A Changing World | 109 |
| 9. | Then and Now | 117 |

# Acknowledgments

This book would not exist without the vision and dedication of Terry Berry and the Board of Trustees of the Amador–Livermore Valley Historical Society. I was privileged to spend a summer in the archives and photographic collections located at the Museum on Main Street in downtown Pleasanton, sifting and sorting through hundreds of photographs while trying to narrow down the selection. Obviously many difficult choices had to be made. My primary goal in choosing these photographs was to tell a cohesive story, as well as to illuminate the visual past. Since Pleasanton history has been documented in several pictorial histories, it was important to try and combine familiar photographs with lesser-known finds. Throughout the process, I was aided by the museum's wonderful staff, generous volunteers, and student interns, who helped me find information and scan the photographs. I also want to acknowledge the many volunteers I never met, who over the years spent countless hours collecting, organizing, and documenting the history of Pleasanton and the Amador–Livermore Valley, which made my job extremely easy. I want to personally thank Eric Lunde, a student intern from San Jose State, who researched information for the captions in the book. Most importantly, I want to personally thank Terry Berry, who convinced me to take on this project and kept me going through many interruptions. Our many conversations inspired the framework of this book, and I depended on her good judgment and editing skills when having to make the tough decisions. Although Terry has left her position as museum director to continue her history education, her administrative skills, creativity, energy, and dedication revitalized the museum, setting it up well for the new century. The community of Pleasanton can be proud of the Museum on Main Street. All photographs contained in the book are from the Amador–Livermore Valley Historical Society's collection at the Museum on Main Street, unless otherwise noted.

# INTRODUCTION

The past is present in Pleasanton. The town has effectively managed to preserve its historic past while successfully moving forward into the future. "Planned growth" has included preserving the city's historic heritage, giving Pleasanton an identifiable character. Today the community is home to both the descendants of founding families and new families attracted to the town's historic flavor. Family businesses and large corporations both contribute to this modern city's success, while steady construction of homes and modern business parks around the original town have situated the city as one of the San Francisco Bay Area's thriving suburban business centers.

The valley is rich with natural resources, including abundant water and a good climate; the first peoples lived here for thousands of years before the Europeans arrived in 1769. Spanish reports about the Pleasanton area in 1772 give us only a small glimpse of life in the area. A notation in the Fages-Crespi diary indicated, "Beside a good-sized stream of water we came upon an extremely big heathen village, with perhaps two hundred of both sexes." According to modern anthropologists and early Spanish records, villages of 50 to 200 people lived along the streams crossing the valley. Part of a vast trading network, local Native American residents hunted, fished, and gathered seeds, nuts, and fruits in meadows they had cleared by burning.

Spanish settlement in the Bay Area began with the founding of the mission and presidio in San Francisco in 1776 and the establishment of the Pueblo San Jose and Mission Santa Clara in 1777. Both of these settlements influenced the lives of the local natives, now known as the Ohlone Indians. Life in the Amador–Livermore Valley was even more altered by the 1797 establishment of Mission San Jose in what is now Fremont. By 1805, the Ohlone people in the Pleasanton/Sunol area had either been drawn into the mission system or had retreated to the Central Valley. The valley then became the primary grazing lands for the mission livestock. When Mission San Jose was secularized and converted into a parish church in 1836, the surviving natives disbursed into the surrounding area, with some returning to the Pleasanton area as ranch hands for the newly established Mexican rancheros.

Four ranchos—land grants given to the adult children of prominent Spanish-Mexican families—were established on the former mission lands in the Amador–Livermore Valley. In the area that became Pleasanton, four members of the extended Bernal family applied for and, in 1839, received a 64,000-acre land grant that became known as Rancho el Valle de San José. The rancho headquarters were established along the Arroyo del Valle at a place called Alisal. The Bernals did not move to their rancho but instead remained residents of the San Jose pueblo. A *mayordomo* and hired vaqueros managed the rancho livestock.

In 1848, the Treaty of Guadalupe Hidalgo ended the Mexican-American War and finalized the annexation of California by the United States. The treaty guaranteed the rights of the Mexican landowners, granting them instant American citizenship and full legal protection. Even before Congress ratified the treaty, however, gold was discovered at Sutter's Mill, near present-day Sacramento. The Gold Rush brought thousands of people from all over the world to the area, and California became the 31st state in 1850. Because America had acquired the region by conquest,

most of the newcomers did not willingly recognize the land rights of the Californios (native born Californians of Hispanic descent). Many immigrants saw the huge ranchos, whose boundaries were poorly marked, as unclaimed, and following a well-established American tradition, they squatted on the rancheros' lands. The Bernals responded to this threat by moving to their landholdings in the early 1850s.

The Bernal family included two immigrant sons-in-law, Austrian John Kottinger and American Joshua Neal. Both found their fortunes by marrying into the landed Bernal clan. The Bernals were fortunate that their son-in-law John was trained in the law. When an 1851 congressional act forced Californio landowners to prove title to their lands, he was able to effectively navigate the American legal system. Although the Bernal/Kottinger/Neal clan did sell some land to defray legal costs, the family retained a large portion of their original rancho, and their descendants continued to own land in Pleasanton well into the 20th century.

After a major drought crippled the cattle industry in California in the early 1860s, hay and grain became the valley's major crops. Envisioning the future, Kottinger and Neal surveyed a portion of their lands and established a town named Pleasonton (later changed by clerical error to Pleasanton). They offered land for a station and warehouses to the Central Pacific Railroad. The new rail connection proved critical to the growth of the town. Within 15 years, more than 25 million pounds of commodities shipped from Pleasanton's new depot. New businesses quickly opened, and Main Street took shape.

Although its own underground water supply made Pleasanton quite self-sufficient, the town's economic growth increasingly relied on the economies of Oakland and San Francisco. The small rural community soon became a hinterland to their urban centers. Agriculture dominated the valley's economy well into the 20th century, and many of the town's businesses focused on supplying local farmers. The production of fruits, nuts, hops, sugar beets, dairy products, wine, bricks, and roses all contributed to economic stability.

Pleasanton's reliance on agriculture resulted in a slow-growing population, from 500 in 1869 to only 1,278 in 1940. The beautiful rural environment also attracted visitors drawn by activities offered in the area. Thoroughbred horse breeding and racing at the racetrack originally built by Agostin Bernal appealed to people from all over the world. Luxurious hotels built in downtown Pleasanton accommodated the visitors. In addition, many celebrities and prominent San Franciscans enjoyed weekend visits to the hillside mansion of Phoebe Apperson Hearst, owner of the first Hearst Castle. Even the movie industry made a pit stop in Pleasanton before moving on to Hollywood.

World War II, however, changed the valley forever. During the war, Pleasanton provided housing, USO services, and other entertainments to large numbers of servicemen and women who were passing through the local training bases. The population doubled between 1940 and 1950. Cold war defense facilities also brought more people, but it would take the 1956 National Highway Act to really bring explosive growth. The building of Interstates 580 and 680, combined with Pleasanton's unique location at this major crossroads, resulted in the biggest transformation of all. Suburbanites could now move to the valley and easily commute to San Francisco and East Bay job centers.

In the last 45 years, Pleasanton has transformed from a primarily agricultural town to a bedroom community of single-family homes. Town planners, wishing to diversify and stabilize the city economy, have also brought a major shopping mall, a large industrial park, and numerous businesses to the area. Nevertheless, despite extensive city expansion and significant changes in population demographics, Pleasanton's historic identity remains centered in the core downtown area. In Pleasanton, Main Street U.S.A. is still alive and well.

# One

# CONQUEST AND SURVIVAL

The first people living in the Amador Valley arrived here at least 4,000 years before Spaniards colonized Alta California in 1769. Residing in small villages at the time of European contact, people speaking the Pelen and Causen dialects of the regional Ohlone language lived in the Pleasanton area. Though native populations varied over time, mission records show that 121 Pelen and 71 Causen people relocated to Mission San Jose between 1797 and 1808, effectively ending the non-Christianized Native American habitation in the area.

Due to disease and unhealthful conditions, a large number of natives died in the mission. Because the mission economy largely relied on Native American labor, as mission residents died, missionaries went farther inland to recruit more native people. By the time Mission San Jose closed in 1836, approximately 1,500 natives speaking nine different languages lived at the mission; of these, only about four percent spoke Ohlone.

After Mission San Jose closed, the Mexican government distributed the mission's grazing lands as grants to local Spanish-Mexican families. Some of the former mission natives went to work for the Bernal family on Rancho el Valle de San José. Eventually a Native American community, the Alisal Rancheria formed on the property of Agostin Bernal southwest of present-day Pleasanton. This community was composed mostly of people who spoke the Plains Miwok and Northern Valley Yokuts dialect, plus a few who knew the Ohlone language.

The Native Americans of Alisal worked throughout the valley as laborers, ranch hands, and servants. They built adobes, picked hops, and worked at the Hacienda del Poza de Verona, the home of Phoebe Apperson Hearst. Although the population steadily declined from the 1890s, Alisal remained an independent community until 1914, when a fire destroyed the village.

Through the years, many native people either left the area or mixed with nonnative peoples, often losing the memories of their heritage. Fortunately descendents of the families who once lived at Alisal preserved some of their knowledge of the *rancheria*. Today these descendants honor their heritage by educating people about Ohlone culture and history.

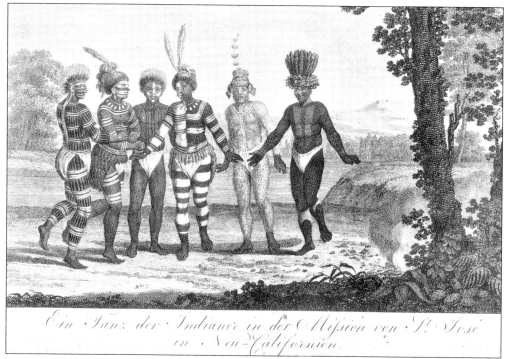

Foreign visitors to Mission San Jose, c. 1806, saw this special dance performance by a group of Native Americans, who were from different regions of Northern California. The native second from the right is believed to be Ohlone. This drawing by Georg Heinrich von Langsdorff, a scientist on the Rezanov expedition from Russia, is considered one of the earliest depictions of these people. (Courtesy Bancroft Library.)

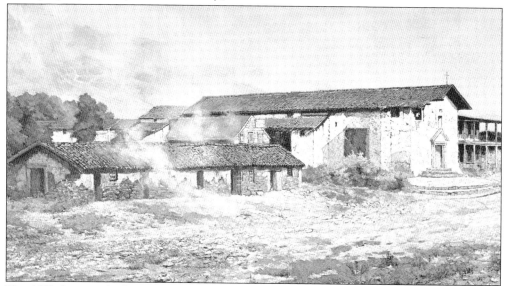

This 1852 photograph of Mission San Jose shows the deteriorating original mission church and adobe buildings after the conversion of the mission to St. Joseph's Parish. The church structure in this picture was destroyed during the 1868 earthquake on the Hayward Fault. A new church, recreating the look of the original mission structure, was finished in 1985. (Courtesy Bancroft Library.)

This photograph was taken of Chief Tarino near Alisal Rancheria in 1887. Chief Tarino, a leader of the Alisal community, worked for John Kottinger. Many descendents of the people who lived at Alisal are now active in preserving their heritage, making sure that Native American remains discovered in the Pleasanton area are properly identified and reburied at the Ohlone Cemetery in Fremont.

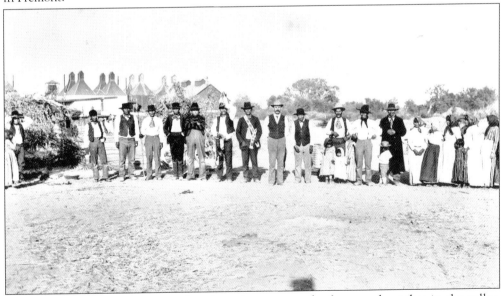

In the American period, natives found employment on the farms and ranches in the valley. Shown here are Native American workers in the hop fields of Pleasanton in the late 1800s. Natives often posed as Mexicans to avoid discriminatory treatment. By 1910, the Native American population of California had declined to less than 15,000 from the pre–European contact estimate of 310,000.

In 1886, George Hearst purchased land in Pleasanton, including the Alisal Rancheria, where 125 Native Americans still lived. The Alisal residents became known as the Verona band of Ohlone Indians, named after the Western Pacific Railroad station built to serve the Hearst family. This house was used by Native Americans who worked on the Hearst Ranch.

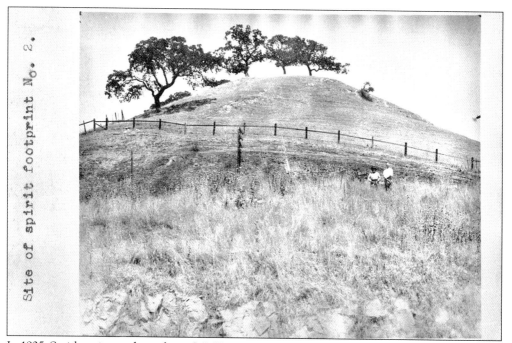

In 1925, Smithsonian anthropologist J. P. Harrington came to Pleasanton to interview local Native American survivors about their language and culture. Pleasanton businessman Ernest Schween introduced Harrington to José Guzman, a native who had once lived at Alisal. Together they helped Harrington locate the footprint of the Alisal Rancheria in the hills southwest of Pleasanton.

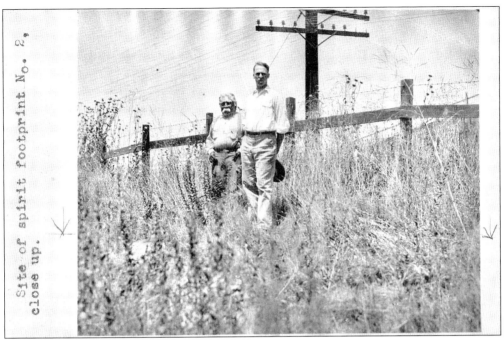

This 1925 close-up of José Guzman and Ernest Schween was taken on the land where the Alisal Rancheria was once located. In 1905, the Special Indian Census showed 70 people still living at Alisal. A 1914 fire destroyed what was left of the village, and the last Native Americans left the rancheria forever. Most of the area where the village was located is now buried under Interstate 680.

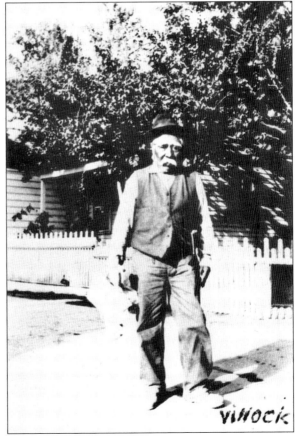

Known around Pleasanton as "old Indian Joe," José Guzman was born near Dublin in 1853. His parents found work at Rancho San Ramon after leaving Mission San Jose. Orphaned by age 12, Guzman spoke three languages: Chochenyo (an Ohlone dialect), Spanish, and English. He died in 1934 in Pleasanton. José was an important source of information on the lives of descendents of former mission natives and the Alisal Rancheria.

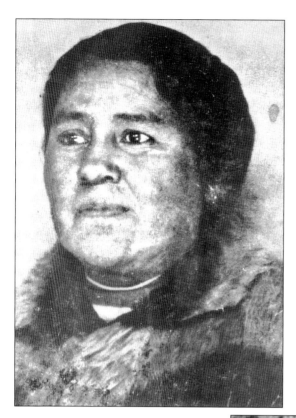

Dolores Marine Galvan (1890–1982) was of Ohlone, Bay Miwok, Plains Miwok, and Patwin descent. Born in 1890 across the street from Mission San Jose, Dolores later lived at the Alisal Rancheria and worked as a domestic for Phoebe Hearst, whom she referred to as "Aunt Phoebe." In 1965, Dolores fought successfully to keep Cal Trans from building Interstate 680 through the Ohlone Indian Cemetery in Fremont.

Andrew Galvan, a descendent of Chief Tarino, is an Ohlone historian and curator of Old Mission Dolores in San Francisco. The Ohlone Indian Tribe, Inc., established by the Galvan family, maintains the Ohlone Indian Cemetery in Fremont. Andrew has consulted on the many discoveries of native remains in the Pleasanton area. The Ohlone are still trying to regain their status as a nationally recognized tribe. (Courtesy Gerry Mooney.)

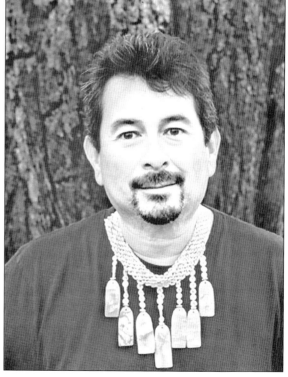

## Two

# A Family Affair

Pleasanton had its beginnings as a Mexican land grant to members of the Bernal family of San Jose. Because it originally had been part of the lands belonging to Mission San Jose, the 1839 grant from Gov. Juan Alvarado became known as Rancho el Valle de San José. The new owners were two brothers, Agostin and Juan Pablo Bernal, and their brothers-in-law, Antonio Maria Pico, husband of Maria Pilar Bernal, and Antonio Maria Sunol, husband of Maria Dolores Bernal.

The four Bernal siblings were the grandchildren of Juan Francisco Bernal of Sinaloa, Mexico, who had brought his family to California on the 1775–1776 Anza expedition that founded the San Francisco presidio and mission. The Bernal siblings grew up in San Francisco and San Jose, eventually moving with their parents Jose Joaquin Bernal and Maria Josefa Sanchez to their Santa Teresa Rancho, south of San Jose. As their families grew, the brothers and their sisters' husbands applied for their own rancho in the Amador–Livermore Valley.

The families did not immediately move to their new lands. In 1836, Antonio Maria Pico built a house in the eastern portion of the rancho (now Livermore), but after selling his share to Antonio Maria Sunol in 1842, he returned to San Jose. The Bernal brothers remained in San Jose until after the Gold Rush, when it became necessary to move to the rancho to protect their holdings. Sunol sold Pico's share of the rancho in 1849 to Juan Pablo Bernal for $2,000 but kept his own portion. There, in the town now bearing his name, Sunol built an adobe he never inhabited.

By the 1850s, the rancho's herds included about 25,000 cattle, several thousand sheep, and 1,000 horses. The Bernal family prospered by selling cattle to the hungry forty-niners and other California immigrants. The brothers built adobes, settled their families in the valley, and gave land as dowries to two of their daughters, the wives of John Kottinger and Joshua Neal. Although the holdings were mostly divided among the many Bernal children, lots were also sold to incoming settlers and a small town took root.

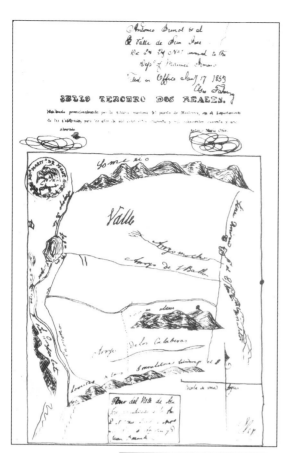

This *diseño* (map) of Rancho el Valle de San José was prepared by John Kottinger, who represented the Bernals in their 1852 claim filed in response to the U.S. Land Act of 1851. The act required land grant owners to prove their title to the land before an American land commission. Thanks to their son-in-law's legal training, in 1865 the commission confirmed 48,436 acres of the original 64,000-acre grant.

This 1871 survey map shows the four valley ranchos, the biggest of which was the Rancho el Valle de San José. The smallest, Rancho Santa Rita, was granted to Dolores Pacheco. The Amador–Livermore Valley was named after the first two grantees, José Amador of Rancho San Ramon and Robert Livermore of Rancho Las Positas.

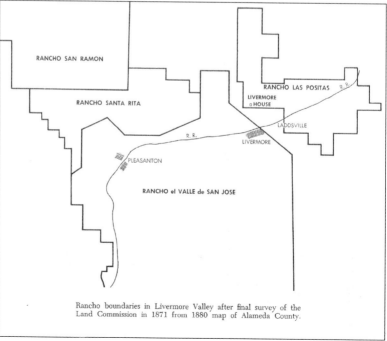

Rancho boundaries in Livermore Valley after final survey of the Land Commission in 1871 from 1880 map of Alameda County.

Agostin Bernal (right), born at Mission Dolores in 1797, was a soldier from 1819 to 1827. He married twice and had 14 children. After the death of his first wife, he married Maria Juana Higuera (below), 27 years his junior, at Mission Santa Clara in 1841. Agostin started building an adobe on his portion of Rancho el Valle de San José in 1848 and moved his family there from San Jose in 1850. In 1860, Agostin built a racetrack on land east of his adobe. Today Division Street approximately marks the dividing line between Agostin's and Juan's portions of the rancho. When Agostin died in 1872, his funeral procession to Mission San Jose was said to be one of the largest ever seen.

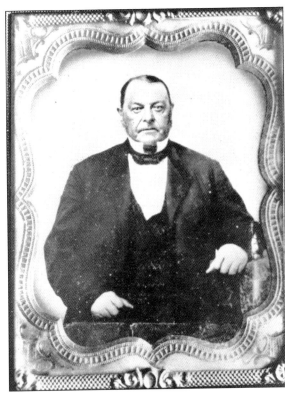

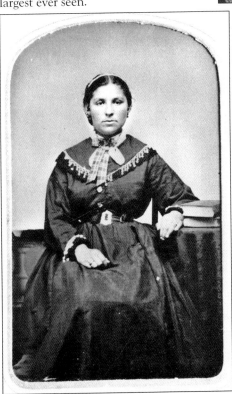

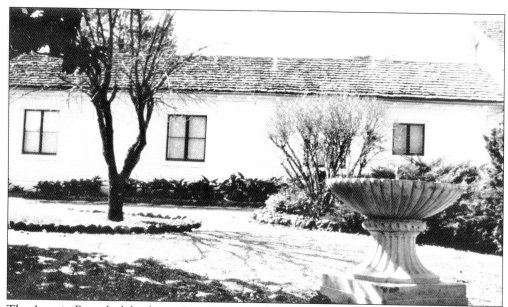

The Agostin Bernal adobe, located south of Bernal Avenue on what is today Foothill Boulevard, consisted of six rooms with 2-foot-thick, white, lime-plastered walls. The Bernals imported a hand-painted wooden fireplace inlaid with tile from Spain. This rear-view picture of the adobe, c. 1950, shows it incorporated into a larger home, the reason it still stands today.

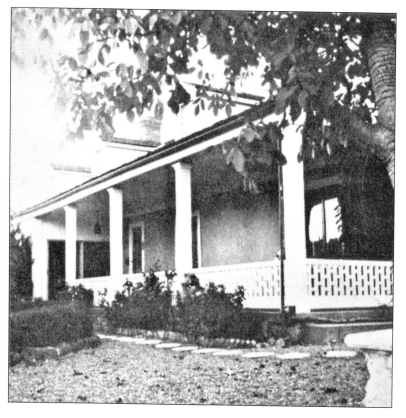

The Agostin Bernal estate sold 500 acres and his adobe to Joshua Chadbourne in the 1870s; then, around 1916, Harry Baldwin bought the property and raised Hereford cattle on the land. San Franciscan Walter Johnson purchased the acreage in 1940, repaired the disintegrating adobe, and integrated it into a larger home that he used as a weekend retreat. John Madden now owns the historic site.

Younger brother Juan Pablo Bernal (1810–1878), at right, married Rafaela Feliz (1817–1871), below, in 1832. While living with his parents on Rancho Santa Teresa, they had five children: Maria Refugia, Francisco, Guadalupe, Teresa, and Juan. In 1852, the family moved to their new adobe at the Rancho el Valle de San José. Concerned about the land claims process and the likely loss of land, Kottinger advised Juan Pablo to divide his portion of the rancho among his wife and children, which he did. Juan Pablo maintained homes in both Pleasanton and San Jose until his wife died, then moved permanently to a newly constructed house on Vine Street in San Jose.

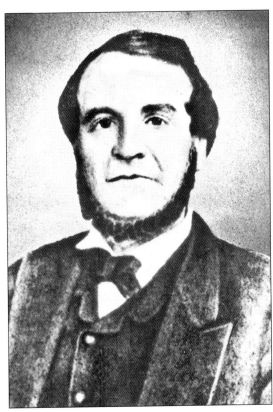

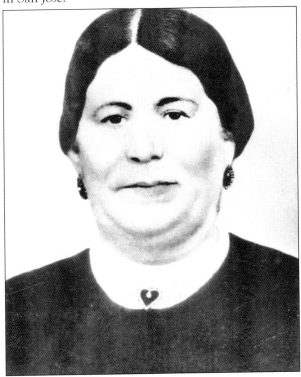

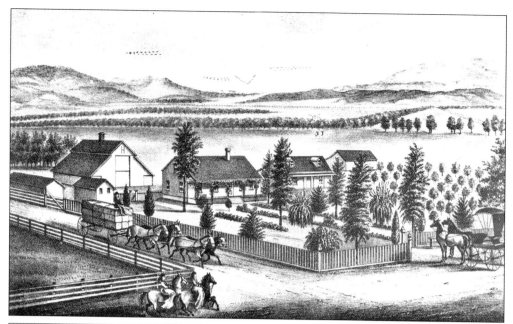

This highly idealized 1878 drawing of Joseph Black's farm includes the original adobe of Juan Pablo Bernal. Bernal built his adobe on the north side of the Arroyo del Valle, on what are now the tennis courts of Amador High School. He sustained huge losses of cattle in the drought of 1862–1864 and eventually sold his last 7,000 acres to Black in 1870.

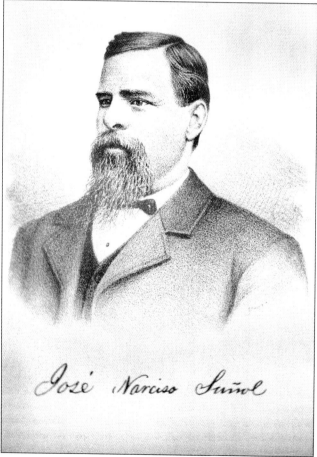

Jose Narciso Sunol, born in San Jose in 1835, was the oldest son of Antonio Maria Sunol and Maria Dolores Bernal. His father, a sailor from Barcelona, came to Monterey in 1818. Jose Narciso was educated in Europe before returning to live in the adobe his father built near the present Sunol Water Temple. He married Maria Rosario Palomares in 1858, and they had six daughters.

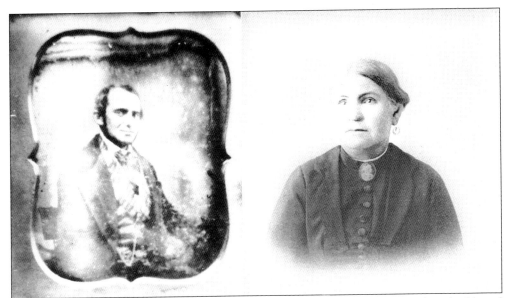

Born and educated in Austria, John William Kottinger (1818–1892) immigrated to the United States in 1846 and to California in 1849. He settled in San Jose and became a schoolteacher, translator, and notary. In 1850, he married one of his pupils, Maria Refugia Bernal (1835–1915), sent by her father, Juan Pablo, to the school to learn English.

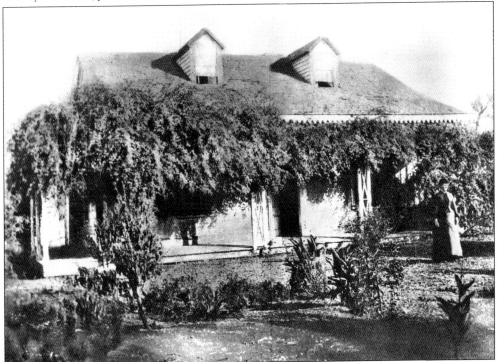

In 1852, Kottinger built this house on land his wife received as a dowry. The Kottingers lived in the home on the south bank of Arroyo del Valle from 1852 to 1857. After living briefly in San Francisco, in 1862 they returned to the residence. Known for the white roses that covered the porch, the adobe was torn down in 1930.

In 1851, Kottinger built this adobe barn, still standing today on the south side of Ray Street. After Alameda County was formed in 1853, John Kottinger was elected the first justice of the peace of Murray Township. He held court in his house and used a portion of the barn as a jail.

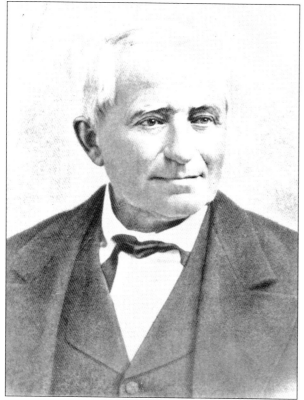

Kottinger became a leading citizen of the growing settlement and eventually cofounded Pleasanton. Besides being the first justice of the peace, he opened the first store, planted the first vineyard, and built the first hotels in Pleasanton. In addition to partnering with his father-in-law in the cattle business, he sold real estate in San Francisco and Pleasanton. Because the Bernals did not speak English, Kottinger's legal services proved invaluable.

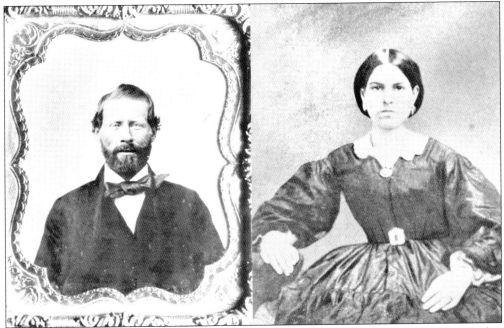

Joshua Ayres Neal (1825–1887) came to California from New Hampshire in 1847 and worked as a foreman for Robert Livermore on Rancho Las Positas from 1850 to 1858. In 1861, he married a daughter of Agostin Bernal, Angela, who received a dowry of 530 acres located just southeast of the Kottinger property. Angela died in 1867, leaving Joshua a widower with two daughters.

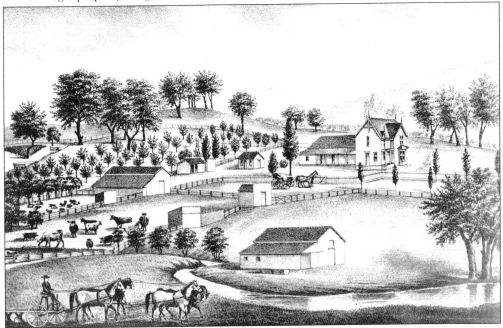

This 1878 sketch from Thompson and West's *Historical Atlas* shows the residence of Joshua and Angela Neal. The property contained numerous mineral springs. Neal later subdivided the land and sold lots east of Main Street to new settlers. He also donated four lots for the first school and sold one lot to the First Presbyterian Church. The Neal house is still standing at 431 Neal Street.

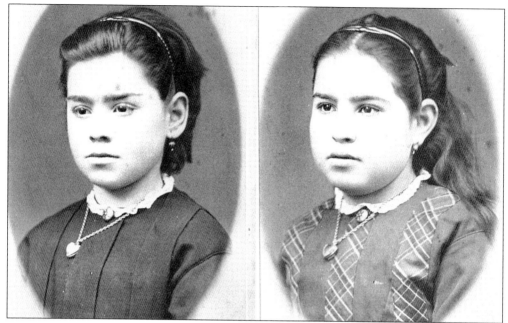

Here are the two daughters of Joshua and Angela Neal, Angelita (left) and Mary. When their mother died, their father sent them to live with his relatives in Boston, where they lived nine years before returning to California. Angelita married T. W. Harris in 1883 and had two sons. Mary Neal Morris married and moved to Los Angeles.

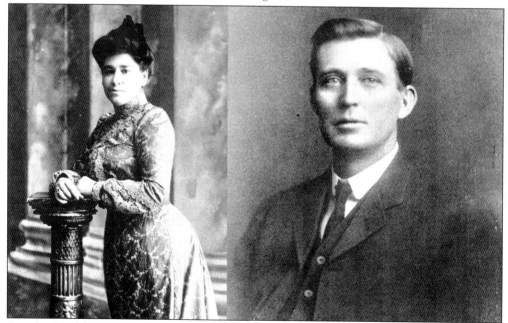

Angelita Neal (1864–1903) married T. W. Harris, who began his career in the hay and brokerage business while studying law at night. He became deputy district attorney for Alameda County in 1898 and district attorney for Oakland in 1903. Harris was appointed Alameda County superior court judge in 1905 and was made a presiding judge in 1928, serving in this position until his retirement in 1950.

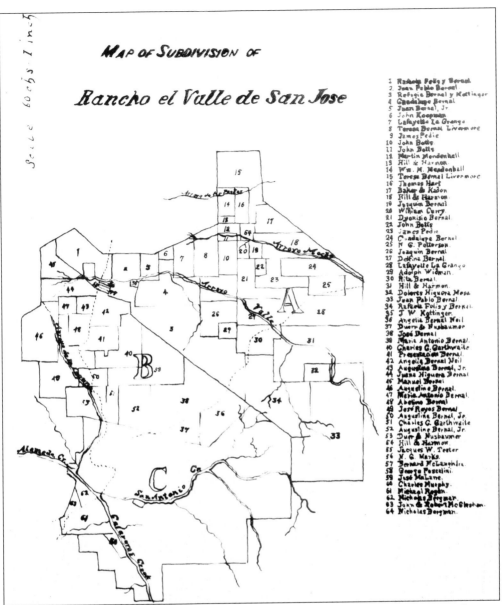

After the U.S. government confirmed the Bernal grant in 1865, an official survey was done in 1867. This map indicates the three sections belonging to the grantees: A designates Juan Bernal's portion, B indicates Agostin Bernal's quarter, and C marks the Sunol land. The partition also shows the plots owned by 21 members of the Bernal family and the other settlers who had claims to the land. Like all families, the Bernals had their misunderstandings. In 1868, Juan Bernal sued Kottinger, whom he claimed had defrauded him of some property in San Jose. In the complaint, Juan stated that Kottinger tricked him into unnecessarily dividing his portion of Rancho el Valle de San José among his children, with Kottinger's wife getting the largest share of land. Possibly bitter over his recent financial losses, Juan Pablo settled the lawsuit out of court and sold the last of his rancho property to Joseph Black in 1870. In Kottinger's defense, compared to many lawyers who made fortunes representing the Californios during the land grant process, he received relatively little for his services.

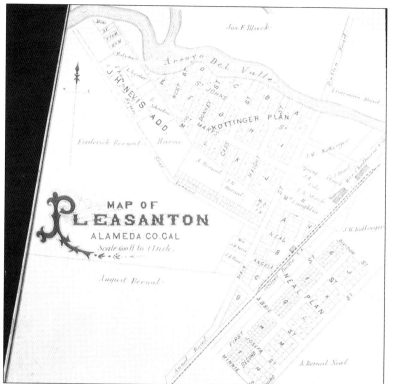

This 1878 map shows the town plan created by Kottinger and Neal in 1868. Both had lost money in the cattle industry early in the 1860s and, now that the title to the land was cleared, they could safely subdivide and sell some of their holdings. In anticipation of the building of the transcontinental railroad, they resurveyed the land and donated 11.5 acres for a depot and other railroad facilities.

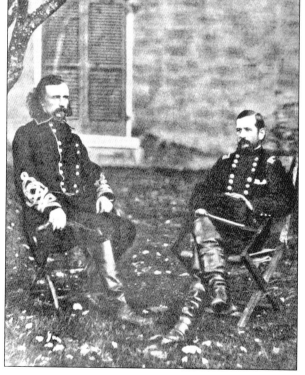

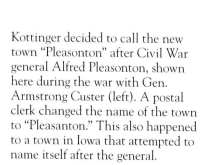

Kottinger decided to call the new town "Pleasonton" after Civil War general Alfred Pleasonton, shown here during the war with Gen. Armstrong Custer (left). A postal clerk changed the name of the town to "Pleasanton." This also happened to a town in Iowa that attempted to name itself after the general.

In 1861, uniting two of the original rancho families, Robert Livermore Jr. (right), son of Robert Livermore of Rancho Las Positas, married Teresa Bernal (below), daughter of Juan Pablo Bernal. Both of them inherited parts of their respective family's rancho. Robert Jr.'s property was located just east of his father's house. Teresa eventually owned two different sections of northeastern Rancho el Valle de San José.

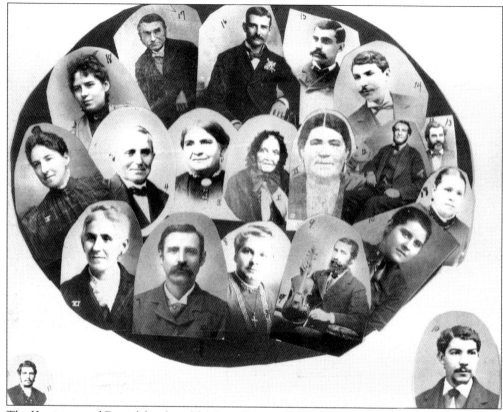

The Kottinger and Bernal family is (1) Maria Castro y Feliz, (2) Rafaela Feliz y Bernal, (3) Maria Refugia Bernal y Kottinger, (4) John William Kottinger, (5) Eva Kottinger, (6) Annie Kottinger, (7) Franklin Kottinger, (8) Magdeline Kottinger, (9) Mathias Kottinger, (10) Martha Kottinger, (11) Guadalupe Bernal, (12) Juan Pablo Bernal, (13) Antonio Maria Pico, (14) John Kottinger, (15) William Kottinger, (16) Alfred Kottinger, (17) Herman Kottinger, and (18) Rosa Kottinger.

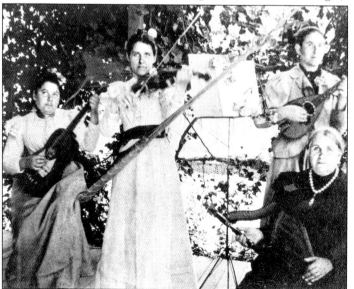

The Californios were famous for both their horsemanship and their love of music. Here Kottinger and Bernal family members carry on their heritage by playing musical instruments, possibly for a family function. From left to right are Martha Kottinger, Magdeline Kottinger, Annie Kottinger, and Maria Refugia Bernal Kottinger.

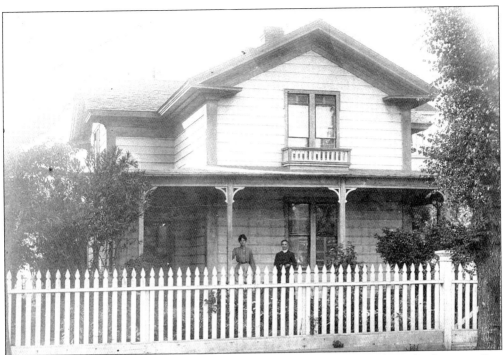

John Kottinger sold his Pleasanton adobe and barn and moved his family to this house in San Jose but maintained a ranch and house in Pleasanton. In 1884, Kottinger subdivided 1,423 acres of his Pleasanton land for the Pleasanton Homesteads subdivision. After John died in 1892, Maria Refugia continued to live in San Jose until her death in 1915.

This house was the last home of John Kottinger and was located at the end of Spring Street, just beyond old McKinley Park. It was designed and built by John's son, William Bradford Kottinger, who was an architect. When this photograph was taken in 1898, another son, Alfred Kottinger, and his wife, Emma Sangmaster, were living there.

Eva Kottinger Burnett (1859–1916), daughter of John Kottinger and Maria Refugia Bernal, was born in San Jose. Educated at the College of Notre Dame and the State Normal School, she was an artist and a teacher. Of her many paintings and drawings, only four remain. Three are in the possession of the Hagemann estate, and one is in the History San Jose collection.

Criselda Bernal was the granddaughter of Bruno Bernal, a brother of the four Bernal siblings who founded Pleasanton. Criselda, shown here in the backyard of her home on Pleasanton Avenue, came to Pleasanton and married her second cousin, Antonio H. Bernal, son of Agostin Bernal. Criselda lived to a ripe old age and spent many hours telling stories of old California to young members of the Bernal family.

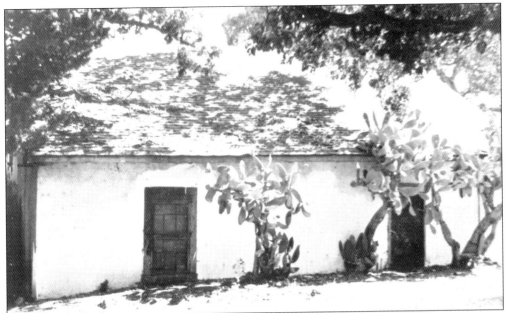

Built in 1854, the Francisco Alviso adobe still stands. Francisco came to the valley in 1839 and worked as *mayordomo* for various rancho owners, including Sunol, the Bernals, Amador, and finally Dolores Pacheco of Rancho Santa Rita. Pacheco sold Alviso one league of his land in 1851, where he built this adobe. Alviso raised cattle and horses and possibly operated the first dairy in the valley.

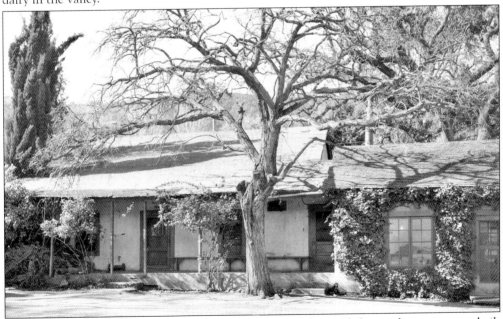

Evidence suggests the smaller structure (right) was built first and the southern structure built later as the Alviso family expanded. Francisco and his wife, Isabel, had 19 children, 10 of whom were living with them in 1860. Francisco sold the last 300 acres of his land and the adobe to J. West Martin for $4,730 in 1872, although four of his children continued to live in the home until 1880.

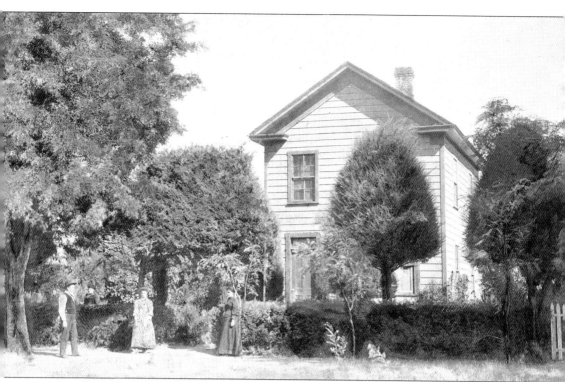

Many histories describe the rise and fall of the Californios, but the descendants of the ranchero families continued as members of their now larger American communities. The families who came on the Anza expedition became Americans just like immigrants throughout American history. As time passed, the large landholdings of the Californios were divided among their large families, lost to the government or squatters, or sold for a profit to new settlers. Here in the late 1800s in front of their home at 4568 First Street (which still stands today) are, from left to right, Antonio, Adela, and Dolores Amador, descendants of José Maria Amador, a brother-in-law of the founding Bernal siblings.

# Three

# PLEASANTON GROWS

By the time the U.S. government confirmed the Bernals' title to the land in 1865, the small settlement of Alisal had been established. In 1863, Kottinger and Neal surveyed some of their property and sold lots to newcomers. The first parcels went to a carpenter, a blacksmith, and a doctor and became the future nucleus of Main Street. Other commercial establishments soon followed, especially after the railroad arrived.

Transportation has always been a key element in the life of any community. In 1867, aware that the Western Pacific Railroad (purchased by the Central Pacific in 1869) would route through Alisal instead of Dublin, Kottinger and Neal resurveyed a portion of their lands and aligned the town's streets with the incoming transcontinental railroad tracks. By the time the train arrived in 1869, the town not only had a new depot and new businesses but also a new name, Pleasanton. The station, on the line between Sacramento and Oakland, was instrumental in securing Pleasanton's future economic stability.

A growing market for raw materials in Oakland and San Francisco increased the value of agricultural property in the Amador Valley, and large landowners began to sell or lease land to farmers. Although stock raising remained an important part of the valley economy, pastureland slowly turned to fields of grain. Wheat, barley, oats, and hay dominated agricultural production well into the 20th century, but other valuable crops, like grapes, hops, and sugar beets, appeared by the mid-1880s. Manufacturing of farm equipment, such as wagons and carriages, and bricks contributed to Pleasanton's stability.

Slow but steady population growth encouraged the establishment of new commercial enterprises and cultural institutions, such as churches and schools. By 1878, Pleasanton had two general stores, four hotels, a bakery, a millinery store, two shoe stores, a laundry, a tailor, a barber, two blacksmiths, a livery stable, and a harness shop. Eventually there were at least 10 hay and grain warehouses in and around Main Street. Today cars instead of horses dominate Main Street, but many original buildings remain from the town's 19th-century past.

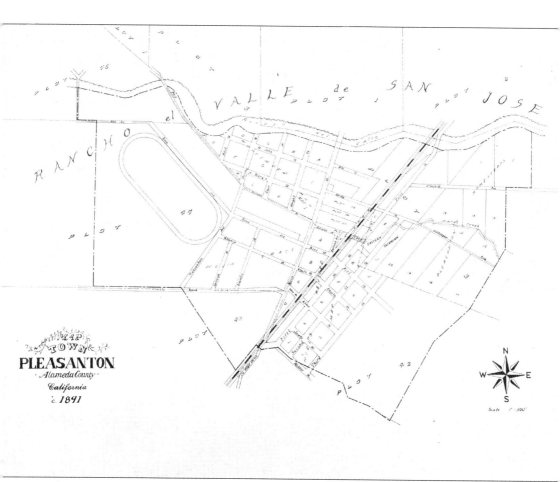

This 1891 map of Pleasanton still shows the basic grid established by the Kottinger and Neal surveys of 1867. Agostin Bernal's racetrack had become a distinctive landmark. Livermore was always the bigger town, both demographically and commercially, but that probably helped Pleasanton maintain its rural nature and historic character. Pleasanton incorporated as a town in 1894.

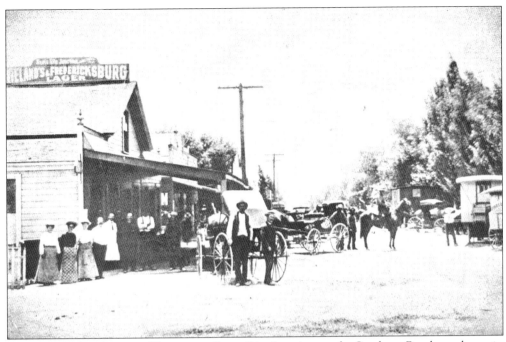

Before the railroad came to Pleasanton, Santa Rita Junction on the Stockton Road was the main stage stop for Pleasanton. By 1900, a small settlement had established itself at Santa Rita, located just north of Pleasanton. In the 1960s, the city of Pleasanton annexed the district.

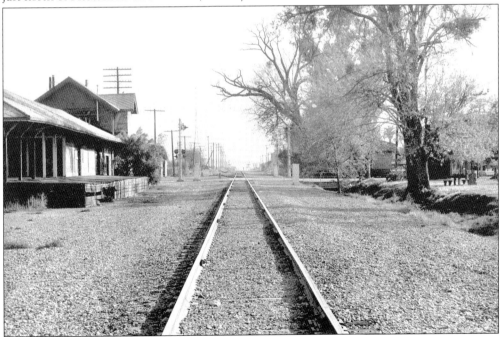

When the Central Pacific Railroad (later the Southern Pacific) came to Pleasanton in 1869, the average price of land in town increased from 25¢ to $100 per acre. By the late 1880s, railcars left the valley loaded with coal, livestock, grain, hay, hops, fruits, vegetables, olives, nuts, brick, wine, sugar beets, and other merchandise. This photograph was taken in 1980.

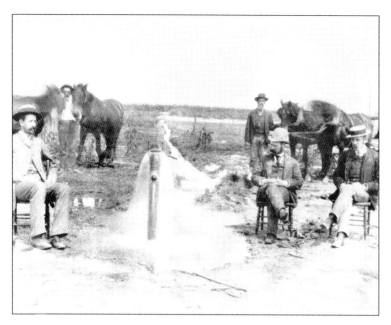

A large reservoir of underground water supplied Pleasanton with an easily accessible source of fresh water. Artesian wells like this one were plentiful, especially in the western end of the valley. Artesian well water flows under natural pressure without pumping. Water was essential to the success of Pleasanton's agricultural activities.

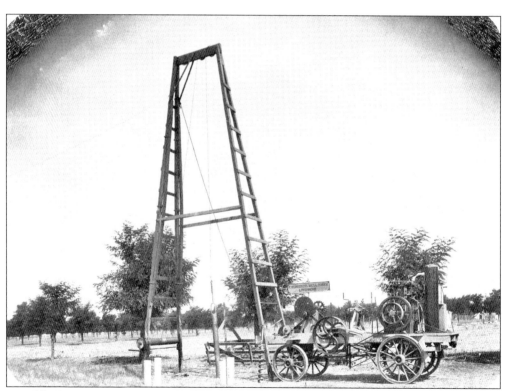

Men like F. W. Brenzel traveled around the valley using the equipment pictured above to drill wells. In 1897, the city purchased an artesian well 67 feet deep, built reservoir tanks, and installed a system of water mains with hydrants. The town trustees also bought two sprinkling wagons so that the dusty streets could be regularly watered.

Joseph F. Black was typical of the incoming American settlers. He traveled from New Jersey to California in 1853, arriving in the valley in 1857. He farmed grain on leased land in the Dublin area before purchasing 7,000 acres from Juan Pablo Bernal in 1870. Black later became one of the major landholders in the valley.

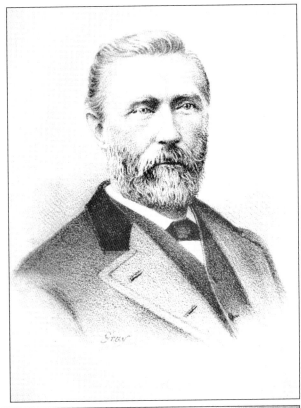

This 1883 photograph of the Black farm on what became Black Avenue does not look much like the idealized version depicted in the 1878 *Thompson and West Atlas* drawing in chapter two. Black eventually had a large grain-growing operation, as well as vineyards, and planted the first 25 acres of hops in the valley.

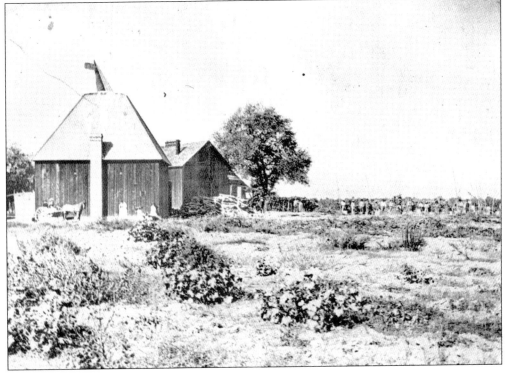

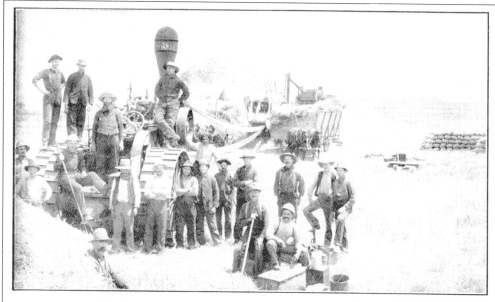

H. P. Mohr and his threshing crew with "Aultman-Taylor" outfit, Pleasanton, Cal.

Here is Henry P. Mohr, standing third from the left on top of the tractor, with his threshing crew, the "Aultman-Taylor" outfit. Harvest season ran from June to October, and migratory farm crews like the one above traveled from farm to farm. Powered by steam engines, stationary threshers had to be moved from one location to another, with food for the workers provided by a chuck wagon.

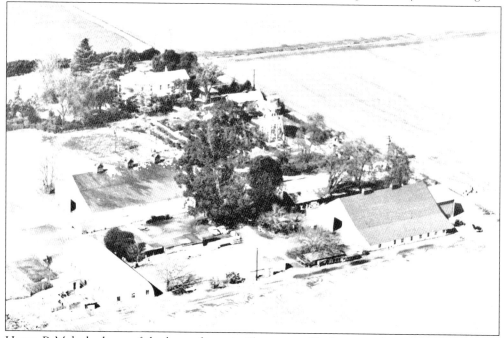

Henry P. Mohr had one of the larger farms in Pleasanton. His home and barns were located at what is now the end of Mohr Avenue. The farm was acquired in 1885 from John English, who had purchased it from José Amador. By 1901, Mohr's farm was producing 2,270 sacks of grain. Mohr also raised horses and cattle.

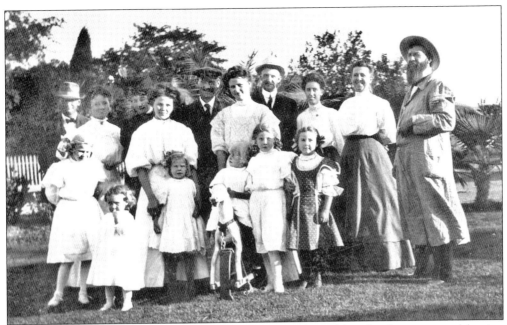

Here are the Schween and Mohr families in the late 1800s, dressed for a family outing or celebration in their Sunday best. In 1893, Henry Mohr, far right, married Ernestine Schween, second from right, and together they had five daughters. There are descendants of both families still living in Pleasanton today.

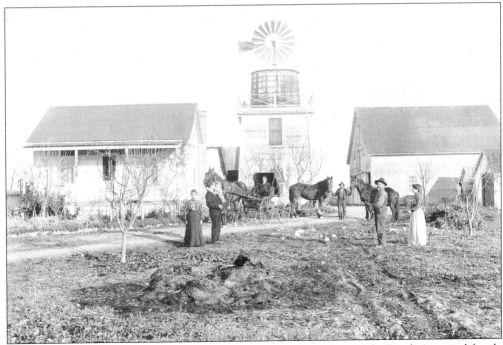

This 1895 photograph shows the DeFreitas family farm located on Mohr Road. A typical family farm had a house, a barn, and a water tower with a windmill. Many Portuguese, Irish, and German immigrants came to the valley and became prosperous farmers and businessmen.

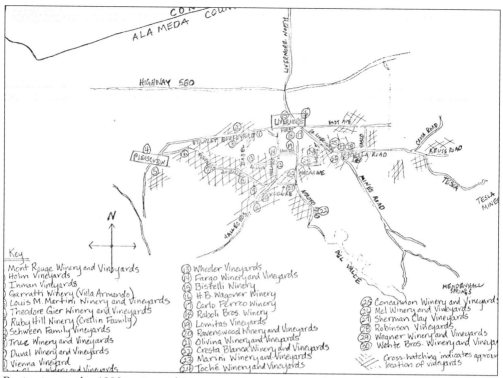

Beginning in the 1880s, winemaking emerged as a major industry in the Amador–Livermore Valley. John Kottinger is credited with bringing the first grape cuttings from Austria. He later had a 12-acre vineyard at his ranch in what is now the Vintage Hills area of Pleasanton. This map shows the locations of 30 local vineyards and wineries. Although Livermore dominated the trade, Pleasanton had its share of important wineries.

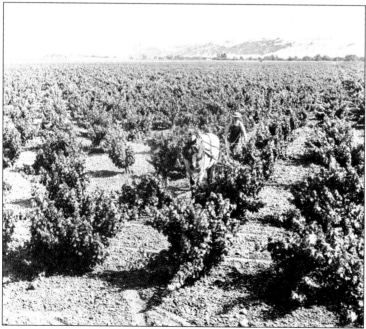

Usually located on high ground, early vineyards grew without irrigation. By the 1870s, Chinese workers dominated the fields, but after the Chinese Exclusion Act passed in 1882, Italian and French immigrants took their place. Prohibition in 1918 crippled the valley industry and, by the 1933 repeal of Prohibition, over 4,500 acres of vines were reduced to 1,100. The wineries made a slow comeback through the rest of the century.

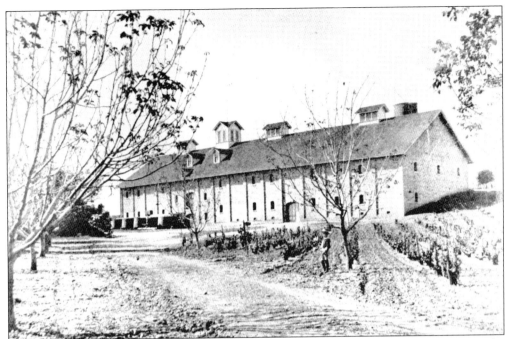

In 1887, John Crellin constructed the Ruby Hill Winery, shown here in 1897, about three miles east of Pleasanton. It was later purchased in 1920 by Ernest Ferrario, who operated the winery until 1974. A fire destroyed the winery in 1989, but it was rebuilt using many of the original bricks and the original keystone over the entry. Ruby Hill is now the Mitchell Katz Winery.

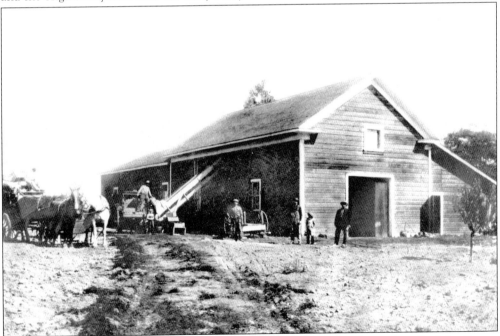

Founded in 1902 by Frank Garatti, the Villa Armando Winery was located on St. John Street. Anthony Scotto purchased the winery in 1962 and continued operations in Pleasanton until a 1980s lawsuit forced the closure of the facility.

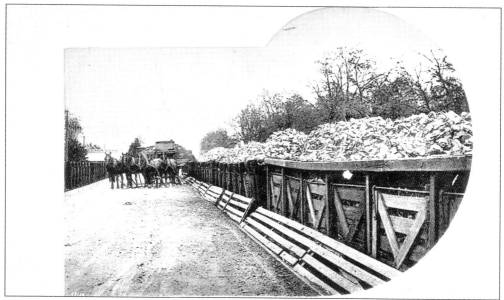

By the 1890s, sugar beets were a profitable crop, and local farmers employed as many as 200 workers. This 1912 photograph shows the loading of the sugar beets for shipment to the processing plants in Alvarado (now Union City). Nearby residents complained of the odor from the beet pulp left in the cars. Sugar beets remained an important commodity in the valley into the 1950s.

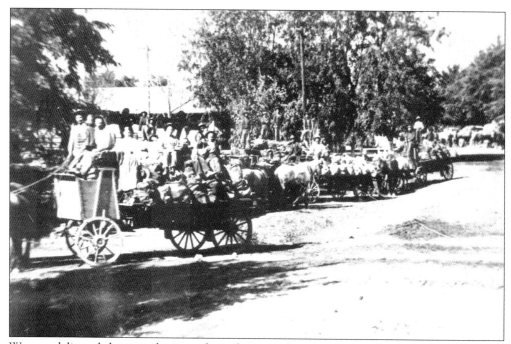

Wagons delivered the sugar beets to the railcars in Pleasanton. Second Street was widened to accommodate the farm traffic. Many of the workers in the sugar beet industry were Japanese, East Indian, or Filipino. They would often hitch a ride on the wagons from the fields to town.

The Remillard Brick Company established a branch operation in Pleasanton in 1889. After Remillard died in 1904, his wife and daughter, Lillian, managed the operations until 1936. The brickworks were located on the east side of Stanley Boulevard, just outside of town. During the peak summer period, the plant employed over 200 people. The 1906 San Francisco earthquake damaged the smokestacks in this picture.

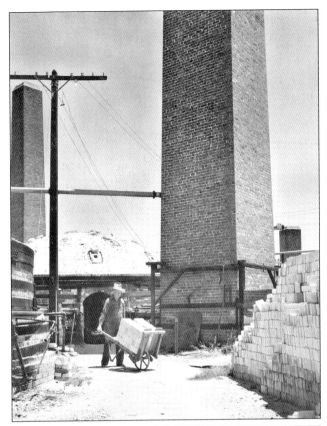

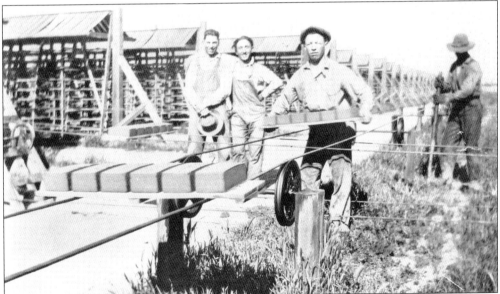

Most of the workers at the Remillard Brickyard were single men, many of whom were Italian and Portuguese immigrants. Boardinghouses and shacks, as well as a company kitchen staffed by Chinese cooks, were located on the property. The brick business declined during the Depression and, after a fire burned down the plant in 1936, the company closed.

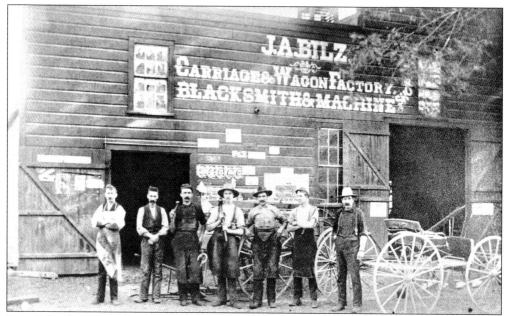

J. A. Bilz, who received a patent in 1882 for a two-wheeled buggy known as the Bilz Excelsior, opened his carriage and wagon factory at 680 Main Street in 1865 and constructed this building in 1868. Bilz may have been the first downtown businessman to encourage fire protection when he installed a small hydrant and large water barrels all around the shop.

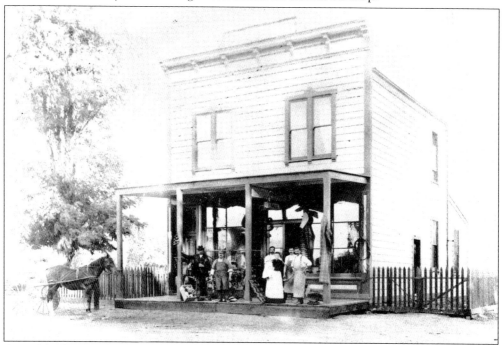

One of the first commercial buildings with large display windows, C. H. Dall Harness and Saddlery opened in 1889 at 520 Main Street. The shop crafted leatherwork for ranching and horse-racing needs, including those of Phoebe Hearst. Shown here are Chris and Marie Dall and their son, Iver. Living quarters were upstairs. Descendants of the Dall family still call Pleasanton home.

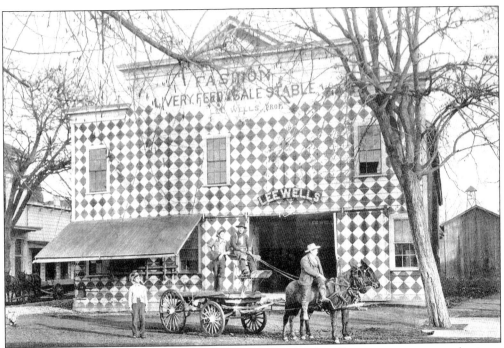

The Fashion Livery, Feed, and Sale Stable, located at 550 Main Street, was a necessary business in the late 1800s. Horses, the main mode of transportation, were boarded by the day, week, or month. Owners A. F. Schweer and Lee Wells also sold hay, grain, coal, and ice.

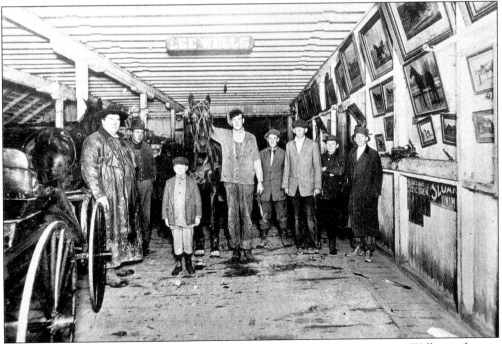

Seen is the interior of the Fashion Livery, Feed, and Sale Stable, with owner Lee Wells standing on the left. With the Pleasanton racetrack conveniently located nearby, Wells also engaged in the buying and selling of horses. Photographs of famous Thoroughbreds can be seen on the right wall.

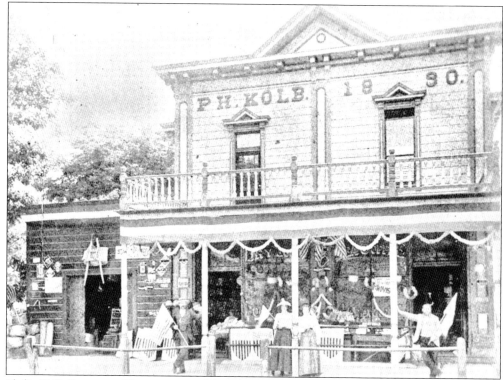

Philip H. Kolb came to Pleasanton in 1878 and opened a bakery, later adding general merchandise to his stock. In 1890, he built this new store at 624 Main Street, home to modern-day Dean's restaurant. Besides this structure, Kolb owned at least 12 buildings in Pleasanton and had large landholdings throughout California. Taken in 1902, this photograph shows the store decorated for a holiday.

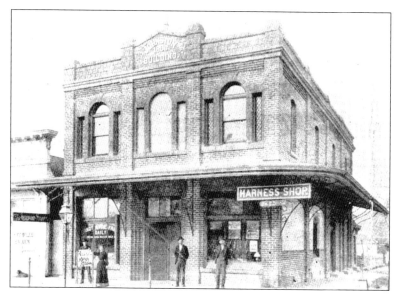

The remodeled and rehabilitated Johnston Building at 465 Main Street still stands. Built by sheep rancher George Johnston in 1896, it has housed a variety of businesses over the years, including a mercantile store, a harness shop, a bakery, and a shoe shop.

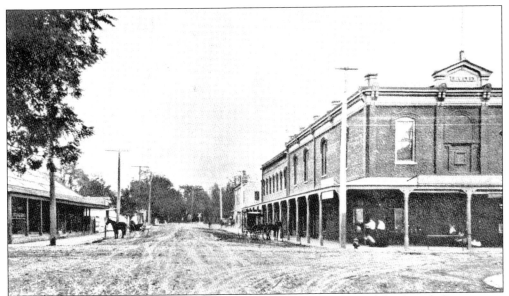

Constructed in 1893 and rehabilitated in the 1980s, this building housed the Arendt Commission House and General Merchandise Store and sold farm produce, supplies, and building materials. H. Arendt and Company also operated a number of large hay and grain warehouses in Pleasanton. By 1935, however, changes in transportation decreased the need for the warehouses, forcing the family to close their business.

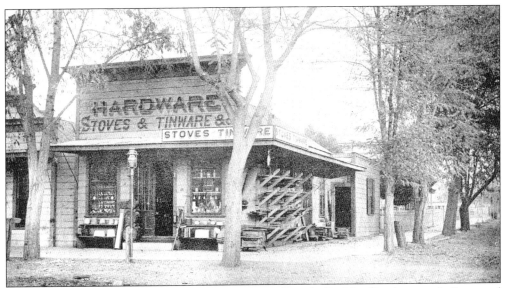

Originally situated on the same site as present-day Kollns, the Pinkley Tin shop was built around 1876. In 1898, this building and the smaller edifice on the left side of the picture were moved onto Division Street, behind the newly constructed Lewis Brothers hardware store. Both of the older structures were dismantled in 2006.

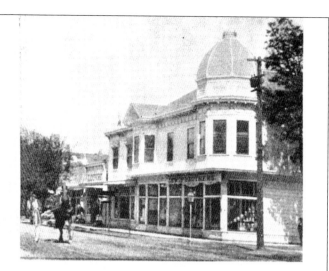

Constructed by Charles Wise in 1898, the Lewis Brothers hardware store was popularly referred to as the "White Corner." Here it is seen in a 1902 advertisement. Little did Frank and Bert Lewis know that the building would become a town landmark.

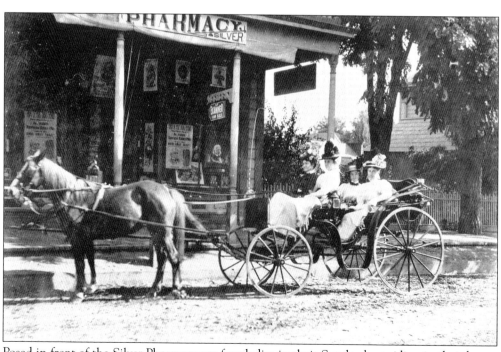

Posed in front of the Silver Pharmacy are four ladies in their Sunday best riding in their buggy in the late 1800s.

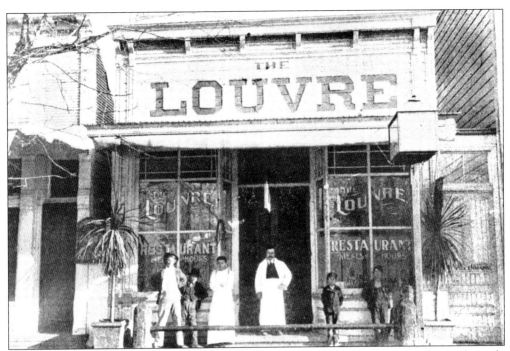

Compared to the number of restaurants now located on Main Street, there were few in the early days. One such establishment was the Louvre restaurant, opened by Mr. Boris and Mr. Arbanasin c. 1890 and located next to the Lewis Brothers hardware store.

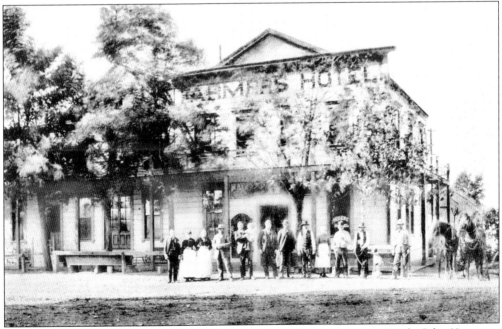

Built alongside the Arroyo del Valle on the north end of Main Street in 1864 by John Kottinger as a "house of entertainment," the Farmers Hotel included a general store. After burning down in 1898, its new owner, Henry Reimers, rebuilt it on the same spot. The new hotel had 14 rooms, a dining room, a bar, and electricity. Today it is known as the Pleasanton Hotel.

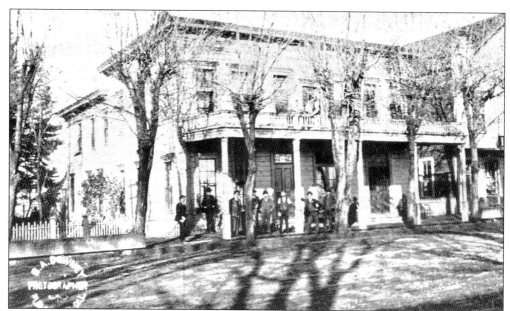

In 1874, John Kottinger built the Germania Hotel at the northwest corner of Main and St. Mary Streets. Kottinger sold the structure to Herman Detjens in 1876 but, when this picture was taken in 1902, it was run by N. Hansen and known as the Pleasanton Hotel. It was demolished in 1931, and a service station now stands on the lot.

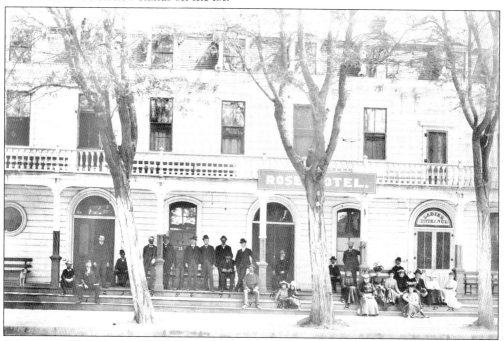

Seen in this 1890s photograph, the Rose Hotel, with its 30 rooms, was the most luxurious hotel on Main Street, and through the years, many famous people enjoyed its first-class accommodations. Constructed by Anton Bardellini in 1863 and named the Pleasanton Hotel, it was purchased around 1881 by Jason Rose, husband to Agostin Bernal's daughter Josephine. The hotel, located at 548 Main Street, was razed in the 1950s.

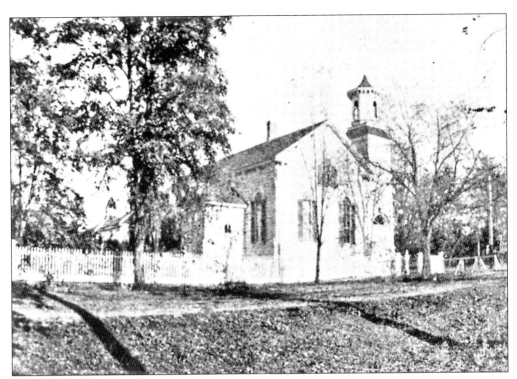

The first church erected in Pleasanton was the First Presbyterian Church, built in 1876 on land purchased from Joshua Neal for $350. Members of the community called a meeting to vote on what denomination the new church should be, and Presbyterians outnumbered all others. This 1888 photograph shows significant additions to the original church. Today it is the home of the Lighthouse Baptist Church.

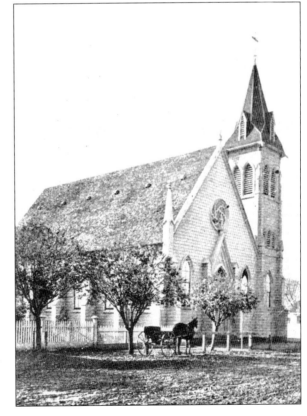

Initially Catholics in Pleasanton attended either St. Raymond's in Dublin or St. Michael's in Livermore, both a considerable distance to travel. In 1882, a church was founded on Rose Avenue and named St. Augustine Catholic Church in honor of Agostin Bernal. This building was demolished when Pleasanton's growth necessitated the construction of a larger church, which opened in 1968 on Angela Street.

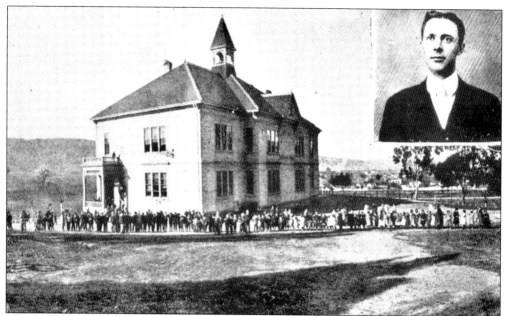

Costing $12,000 in bond money, Pleasanton Grammar School was constructed in 1889 on land donated by Joshua Neal. Located just south of downtown in an area that became known as "Knowledge Hill," the building had eight large classrooms, a large library, speaking tubes, and electric bells. The student body poses here in 1900 with Principal A. E. Weed in front of the building. The school burned down in 1909.

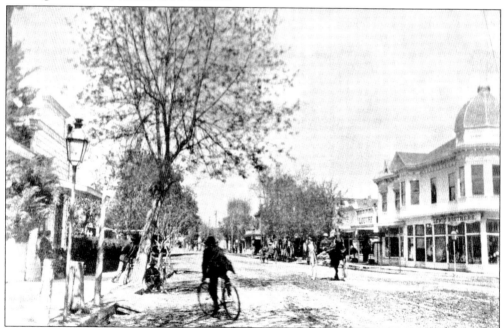

Main Street in 1900 looks quite familiar to the modern viewer, except for the dirt surface and horse and buggy. In the summer, the street was dusty, and in the winter, it was muddy. This view looking north from Division Street represents the 30 years of commercial development that followed the coming of the railroad.

# Four

# HORSES, HOPS, AND COWS

Horses, hops, and cows have had a special place in Pleasanton's history. They provided jobs and opportunities for local businesses, as well as attracting national and worldwide attention. Soil, climate, and geology influenced all three activities.

Soil, climate, and the valley's famous red hay all contributed to the development of horse training and racing in Pleasanton. The sandy clay soil provided a cushion-like track, while the climate made for ideal year-round training conditions. Pleasanton's legacy of horse racing originated with the Bernals. Californios were famous for their horsemanship, and horse racing was a favorite activity during the Spanish-Mexican period. Agostin Bernal's original track, built around 1860, is the oldest continually used track in California.

Known as the *bolsa*, or lagoon, in the early days of settlement, the area south and east of Interstates 580 and 680 became a large lake during the rainy winter months and a swamp surrounded by a thick growth of willows the rest of the year. By the late 1800s, canals were built to drain the area, which encompassed approximately 1,500 acres. Hop fields soon flourished on the newly available land. By the early 1900s, Pleasanton's hop fields were the largest in the state. The money generated by the hop fields contributed significantly to the commercial growth of the town. However, by 1914, numerous factors contributed to a decline in profits, including lower water tables, labor agitation, and World War I. Sugar beets and dairy cows soon replaced the tall fields of hops.

Small dairies had existed in the valley from the earliest settlement, but large dairy operations came to dominate the western valley by the 1920s. Again, readily available water and grain for the cows made it a natural activity. The dairy industry sustained Pleasanton's agricultural economy and its rural nature into the 1960s.

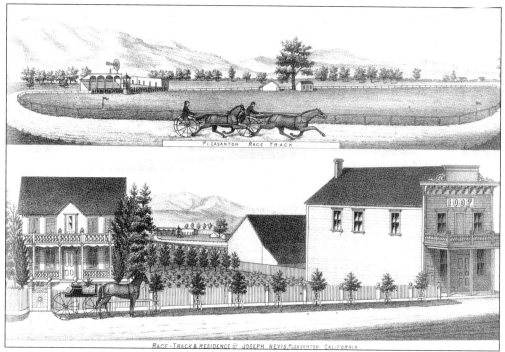

Upon the death of Agostin Bernal, his sons inherited the track. This 1878 drawing shows the racetrack and residence of Joseph Nevis, who married Agostin's widow and purchased the track from his sons. Nevis operated the track as a business venture. (Courtesy *Thompson and West Atlas*.)

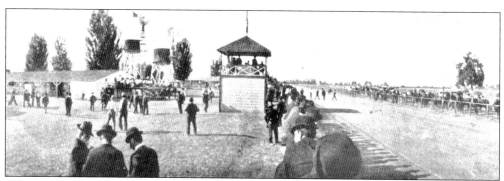

When Australian millionaire Monroe Salisbury purchased the track in 1883 for $25,000, he brought in his own stallions and operated the track as the Pleasanton Stock Farm. Salisbury gained fame for Pleasanton by shipping its red hay with his horses when sending them east for racing. Eastern stables began shipping their horses to Pleasanton for early spring training and racing. This photograph was taken in 1902.

Salisbury acquired a black stallion named Director, a champion trotting horse with a line of famous descendents. Here is Director IV at Mohr Ranch c. 1900. The track had various owners during the late 1800s, including local businessmen and lumber and railroad millionaires. Many California millionaires, including George Hearst, brought their horses to train at Pleasanton.

In 1898, Mr. Heathcote purchased the track and constructed a ranch house, now known as the Heritage House, on the property. A corporation headed by H. F. Anderson (right) bought the track in 1900 and renamed it the Pleasanton Training Track. The group added many improvements, including the expansion of the track into a true one-mile track and the construction of 200 new stalls.

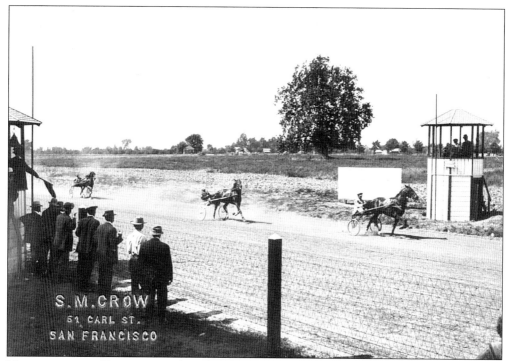

Harness racing at Pleasanton, such as this three-year old pace race in 1910, was very popular by the 1900s. The track's association with fairs started in 1902, when the Golden Gate Fair was held on the site. In 1904, a Pleasanton Fair and Races was held in July. In 1912, the first Alameda County Fair was held on the grounds.

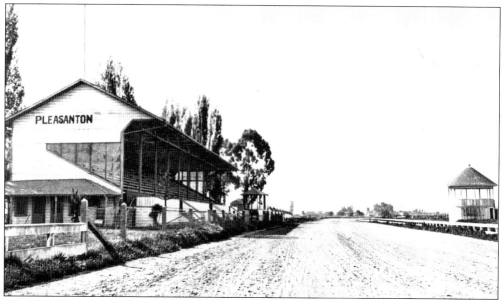

Canadian Roger J. MacKenzie purchased the track in 1911. He spent about $250,000 building a grandstand with living quarters underneath and additional barns for 300 horses. He also added a smaller half-mile trotting track inside the larger track. Unfortunately for MacKenzie, in 1911 betting was outlawed for 20 years. The track, seen here in 1920, was closed from 1916 to 1932.

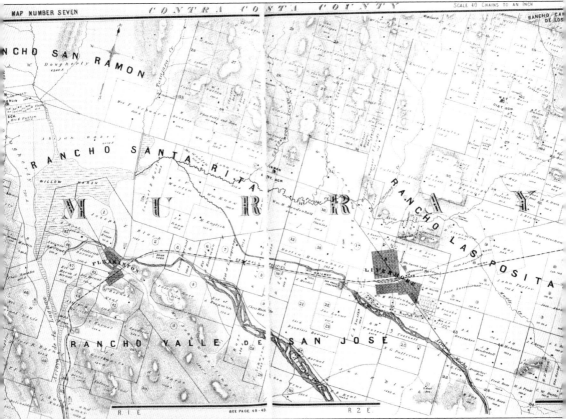

The willow marsh that was once part of a larger seasonal lake is on the left side of this 1878 *Thompson and West* map of Pleasanton. San Francisco's search for a long-term source of water led it to the Alameda Creek watershed and the Amador–Livermore Valley as early as 1875. Water projects in the late 1800s by both the cities of Oakland and San Francisco led to the lowering of the local underground water table. By the 1890s, Spring Valley Water Company, an independent contractor, began quietly buying land in the Amador Valley. By 1912, most of the land and water rights north, west, and south of Pleasanton were owned by Spring Valley, and 100 wells were sending water to San Francisco through Niles Canyon. At one point, experts recommended San Francisco turn the valley into a "great storage basin." Fortunately for Pleasanton, Hetch Hetchy Valley was chosen instead. San Francisco purchased the Spring Valley Water Company in 1930.

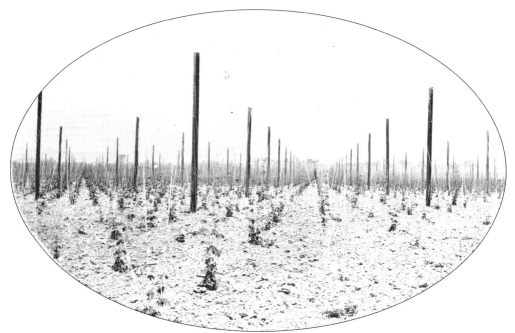

The Pleasanton Hop Company, headed by the Lilienthal family of San Francisco, was formed in the 1890s. The hops were planted in even rows, alongside 20-foot-high poles. Each February, new shoots were tied to twine or wire leading up the trellis. Pleasanton's ideal conditions caused the plants to grow quickly and easily up the lines. In this picture, the shoots are about one month old.

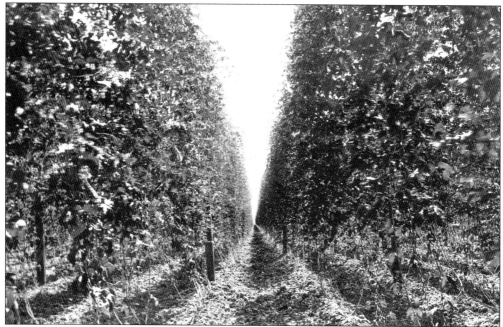

The rows of hops extended more than a mile, and by harvest time in September, the flowering plants reached the tops of the poles. Only the female plants produced the flowers that were picked, dried, and used in the production of beer. These hop fields ran along both sides of what is now known as Hopyard Road.

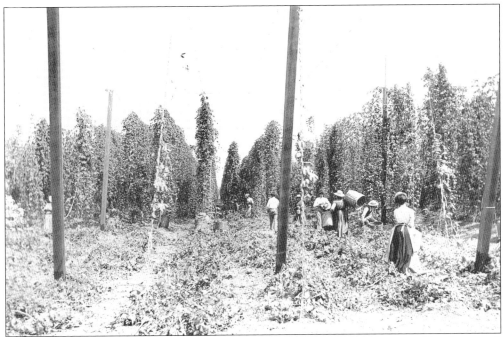

When harvest time arrived, each worker was assigned a row to pick and was paid by the pound. The plants were pulled down from the poles, and the hops were picked and placed in baskets. After weighing, the hops were put in sacks and then transported by wagon to the drying kilns. Men, women, and children all worked the fields, as seen here c. 1900.

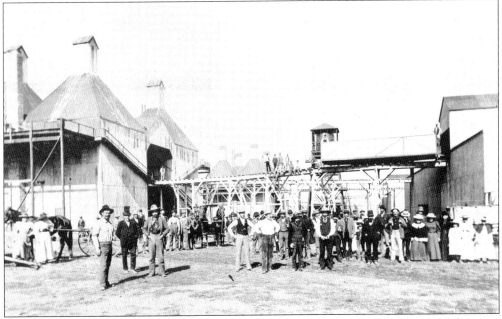

There were a dozen large hop kilns located in what is now the Del Prado area. The kilns were used to dry the green hops before shipping. The hops were taken by elevators to the top of the kilns, laid out on a burlap-type floor, and dried by furnaces that heated the air to 150–170 degrees Fahrenheit. The smoke from the kilns filled the air.

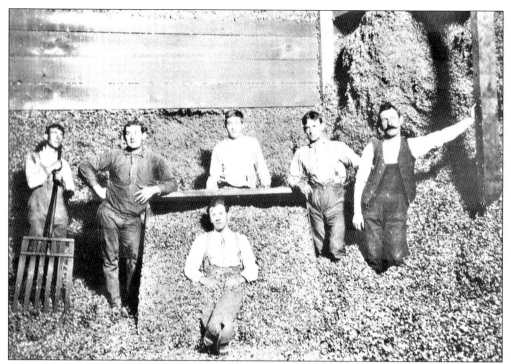

After the hops were dried in the kilns, they were moved by conveyor to the drying barns, where workers used rakes to spread the hops and continue the drying process. When the right moisture content was achieved, the hops were pressed into large bales and stored for shipment in large warehouses.

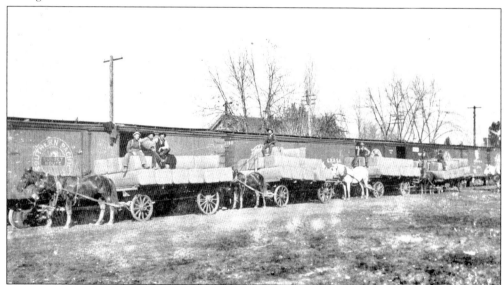

Bales of pressed, dried hops are shown here ready to be loaded on the Southern Pacific train and taken to San Francisco for shipment around the world. In 1893, 148 bales were shipped; by 1897, the harvest had increased to 2,800 bales. The Guinness Brewery in England was a major buyer of the Pleasanton harvest. The high quality and cheap price made Pleasanton hops highly regarded in Europe.

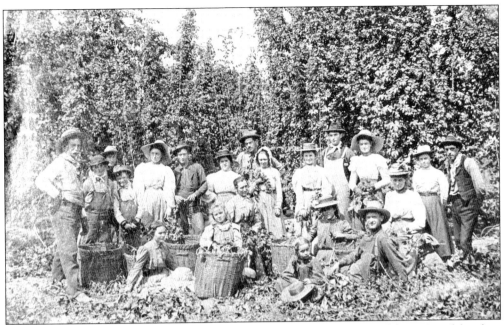

During harvest time, as many as 1,500–3,000 people were employed to pick hops. Local families, as well as migrant workers from far away, came for the harvest. Pleasanton families such as the Castersons, shown c. 1900, picked hops to supplement their regular income. A family of four could clear $100 for three weeks' work. The Casterson family still lives in Pleasanton.

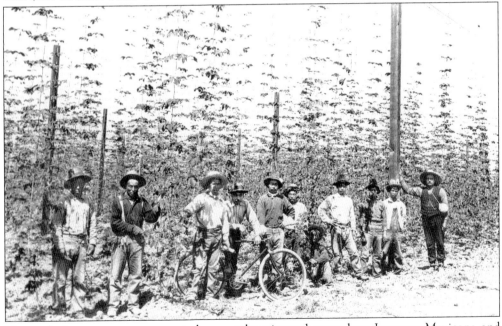

Many ethnic groups were represented among the migrant hop workers. Japanese, Mexicans, and Native Americans all came to work the fields. Unlike local families, the money earned by the migrants was often their main income. Once the hop harvest was finished, they then traveled to other areas of the state to harvest other crops. Paid $1 per 100 pounds, workers averaged $2 to $4 a day.

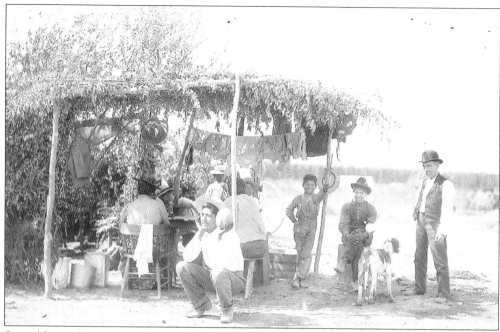

Some Native American workers came from the Alisal Rancheria, while others came from the Central Valley and Mexico. Rather than renting tents, they built brush houses from natural materials. The company insured that all workers stayed for the entire harvest by paying them only a portion of their wages each day; the rest was paid at the end of the season.

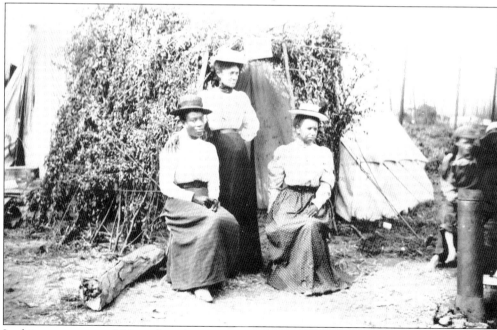

In this scene are two African American women in the camp area of the hop fields. It is unknown whether they worked for the white woman pictured or whether they were independent workers. In 1900, African Americans represented only two percent of the population of California, but this picture does illustrate the diversity of the Pleasanton hop workers.

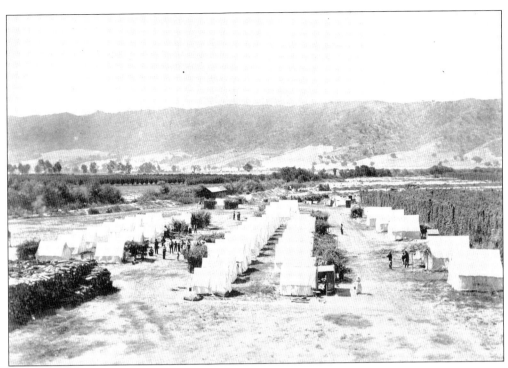

Tent cities were set up alongside the fields. Conditions in the Pleasanton fields were not as bad as some other areas of California. Tents could be rented, artesian wells supplied water, and workers either provided their own food or bought food from grocers, butchers, and bakery wagons that came to the fields.

The town of Pleasanton provided hop workers a free campground located alongside the Arroyo del Valle at the north and east end of Main Street. During the harvest season, many locals complained about the "unruly" hop workers coming downtown and demanded that the city hire a night watchman.

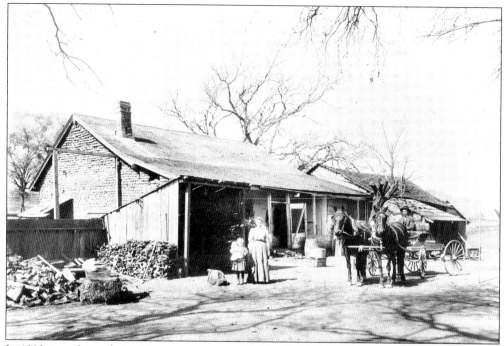

In 1880, in a plan to bring Pleasanton water to Oakland, Anthony Chabot purchased the Alviso Adobe property for the Contra Costa Water Company. The Chabot family sold the property in 1906 to the People's Water Company. One of the tenants during this period was the Kroeger family. Peter Kroeger is in the buggy, and his wife, Henrietta, and daughter, Lena, are standing nearby.

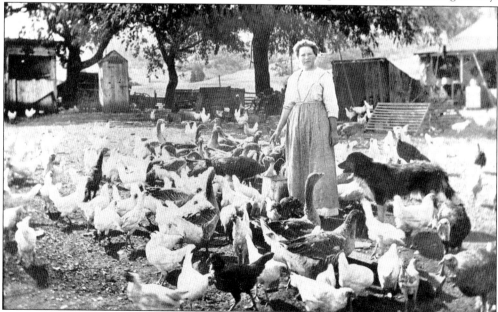

During the Kroeger residency from 1899 to 1912, the water company made some major improvements to the Alviso adobe, including the addition of numerous windows and a wooden floor and ceiling in the southern adobe. Shown is Henrietta (Hattie) Kroeger, in the yard with poultry, in the early 1900s. The property was sold in 1919 to Walter M. Briggs, who founded the Meadowlark Dairy.

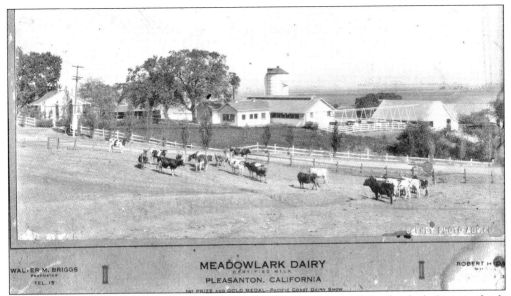

Walter Briggs turned the 152 acres on Foothill Road into the Meadowlark Dairy, which operated from 1923 to 1969. Meadowlark was the first certified dairy in Alameda County, an official recognition that required the highest level of cleanliness. Holstein and Jersey dairy cows dominated the Pleasanton herds because of their abundant production of the butterfat that could be used to make butter and cheese.

In 1950, Dutch immigrants Jannes and Janna Takens responded to an advertisement for a milker and a cook at the Meadowlark Dairy. By this time, the Alviso adobe was used as a dining room for staff and as living quarters for the cook. In 1960, the Takens leased the dairy from Briggs and operated it until 1966, when Briggs's death forced the sale of the land.

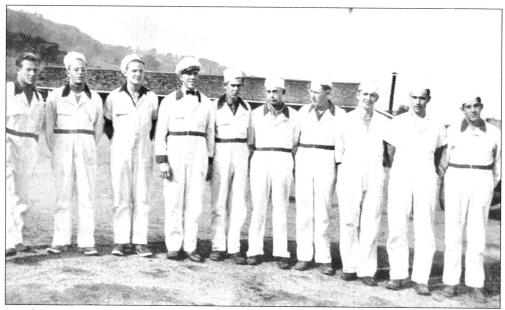

Lined up are some of the dairymen of the Meadowlark Dairy. Many dairy milkers were Swiss or Portuguese immigrants. In order to maintain cleanliness, the uniforms had to be changed daily, or even sooner if they were soiled.

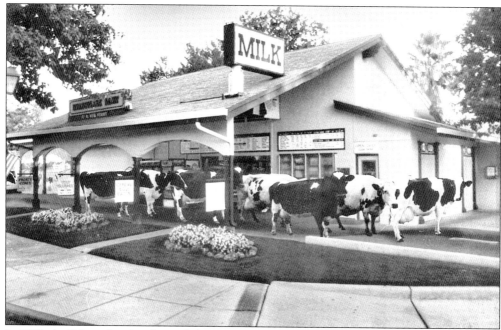

In 1969, the Takens family relocated their processing plant to 57 West Neal Street in Pleasanton. The plant processed 2,000 gallons of milk per day. The drive-in store, shown here in a 1997 business calendar photograph, is still a popular stop for Pleasanton dairy shoppers.

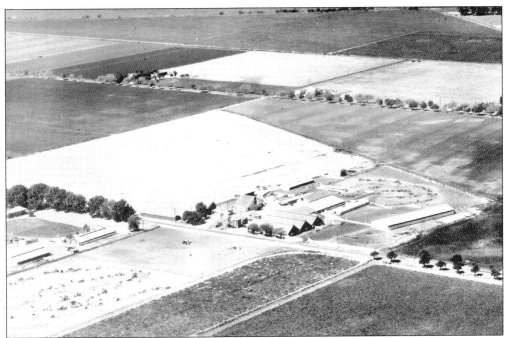

Another prominent dairy in the valley was the Hansen-Orloff Dairy. Hans Hansen and Thomas Orloff formed their partnership in 1921, and together they eventually owned three separate ranches containing 5,000 acres. The ranch pictured above, c. 1940, was known as Hansen-Orloff No. 1. When the partnership ended in 1946, this ranch, located at Black Avenue and Santa Rita Road, became Orloff property.

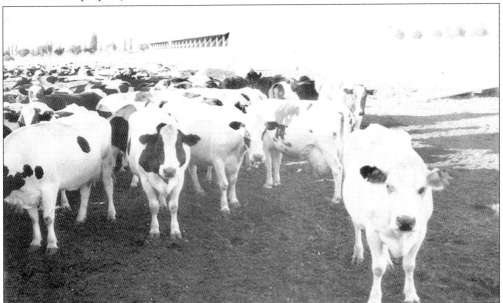

These Holstein and Guernsey cows from the Hansen-Orloff Dairy at one point produced 1,350 gallons of milk per day. The Hansen-Orloff Dairy enlarged its operations by acquiring other local dairies. When Thomas Orloff retired, his son Edwin took over. The Orloff Farms were sold to developers in 1964.

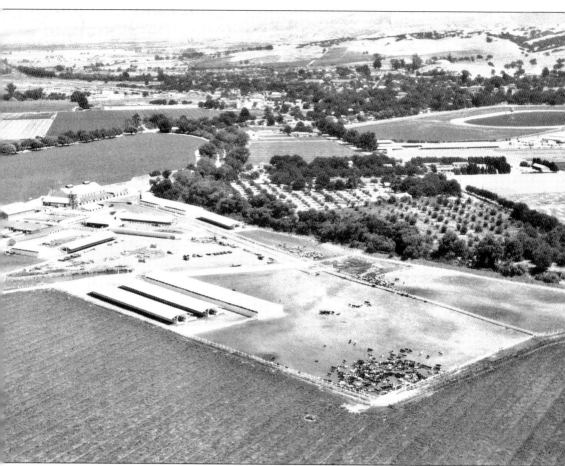

Hansen-Orloff No. 2 was located on the south side of Hopyard Road, just west of the racetrack. This ranch, taken over by Hansen after the partnership ended, became the Hansen-Geiger Dairy. Located in the area of the former hop kilns, the dairy utilized the old hop buildings, plus they added new milk barns. By the 1950s, at least six dairy farms were operating in Pleasanton. In 1966, after 50 years of operations and citing high taxes and increased land values, Hansen auctioned off his 1,400 dairy cows, buildings, and equipment, and sold his land to developers. Timing was everything. The size of the dairy holdings and the increased demand for homes resulting from the building of the new interstates made these lands prime candidates for housing developments.

## Five

# PHOEBE'S CASTLE

The Hearst name is still widely known, primarily because of the legacy of William Randolph Hearst, who built both the extensive Hearst media empire and the celebrated Hearst Castle at San Simeon. Less widely known, however, is the fact that there was an earlier Hearst "castle" in Pleasanton that was built in the late 1890s by Phoebe Hearst, William's mother. Although she never referred to it as a castle, Phoebe's home in the western hills above Pleasanton enjoyed fame during her 1899–1919 residency. The estate later became part of a popular dude ranch and country club before it was destroyed by fire in 1969.

It was George Hearst's hard work and mining genius that made possible the achievements of both mother and son. Arriving in California in 1850, George spent 10 strenuous years in both California and Nevada before achieving some financial success in mining. George then returned to Missouri to deal with his family's estate and, while there in 1862, married Phoebe Apperson. The newlyweds returned to California, where George spent the next 15 years making and losing money in various mining ventures before finally securing his fortune.

George's business interests included some of the largest gold, silver, and copper mines in the United States and Mexico, while his real estate holdings ultimately reached over a million acres. One of his smaller acquisitions was the 1886 purchase of a 453-acre ranch in eastern Alameda County, once part of the Bernal grant. George loved horses and racing, and he planned to use the ranch and the nearby racetrack to build up his horse stables.

Upon George's death, Phoebe inherited George's estate. She chose to make Pleasanton her principal residence, where she built one of the most beautiful homes in the Bay Area. Known as the Hacienda del Pozo de Verona, its Spanish red-tiled roof and white towers could easily be seen from the small town below. From her hacienda, Phoebe managed her late husband's empire and became one of the most generous philanthropists of her generation, supporting a variety of educational endeavors until her own death in 1919.

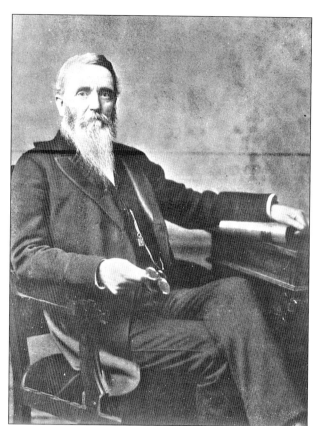

George Hearst (1821–1891), pictured here c. 1888, was appointed to a vacant senate seat by California's governor in 1886, joining California's other senator, Leland Stanford. Hearst won election to the seat on his own in 1888. When he moved his family to Washington, D.C., George postponed development of his Pleasanton property. George died in office only a few years later at age 70.

Below left is the earliest known picture of young Phoebe Apperson (1842–1819), taken about 1862. Born a Missouri farm girl, Phoebe became a schoolteacher before marrying miner George Hearst, 23 years her senior, on June 14, 1862. The portrait below right shows Phoebe Hearst as the prominent and wealthy widow she had become by 1900.

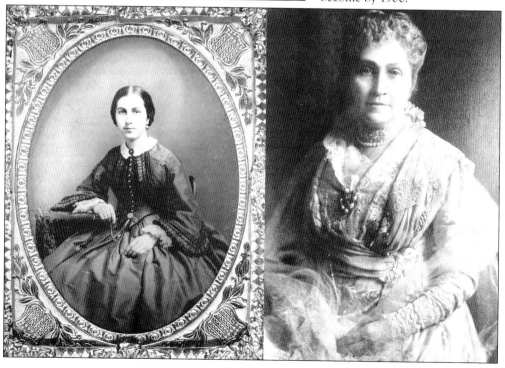

Born in San Francisco, William Randolph Hearst (1863–1951) spent much of his childhood moving from home to home and traveling abroad with his mother. In 1887, George Hearst gave his son Will (a family nickname) the recently acquired *San Francisco Examiner* newspaper to run. After his father's death, Will began using the hunting lodge on the Pleasanton ranch as a weekend retreat.

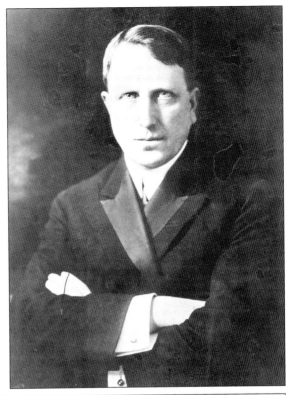

Although the property belonged to his mother, Will hired San Francisco architect A. C. Schweinfurth to design a bigger house for the Pleasanton ranch. In 1896, Will moved to New York to pursue the expansion of his newspaper empire, and Phoebe redesigned the plans, creating the Hacienda del Pozo de Verona. This picture shows the entrance road leading up to the estate.

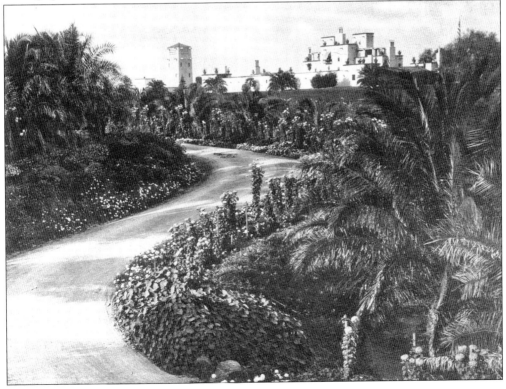

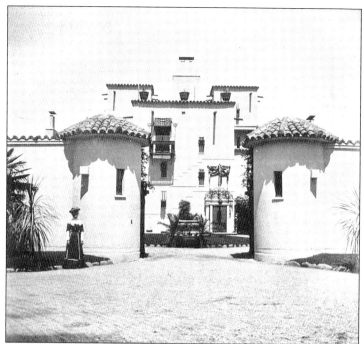

After her husband's death, Phoebe spent the next few years educating herself about her husband's business affairs and settling the estate. Phoebe moved into her new home in 1899, bringing her large domestic staff and many of the furnishings from their home in Washington, D.C. Phoebe is seen in 1902 posing in front of the Moorish-style guardhouses that flanked the entrance to the courtyard.

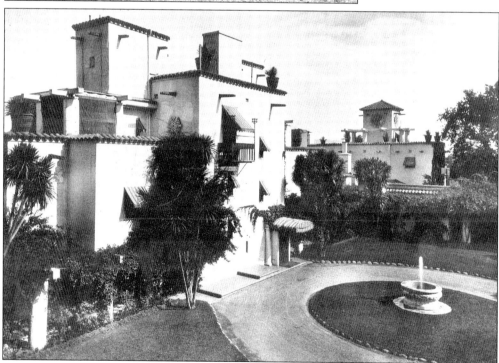

The main residence was three stories high with 53 rooms and two wings connected by enclosed arbors. In the center of the western entrance courtyard was the circular fountain Phoebe had imported from Verona, Italy. The estate took its name from this elaborately carved marble wellhead. Upon Phoebe's death, Will had the well, along with much of the furniture, moved to San Simeon.

Phoebe enjoyed entertaining and held many lavish parties. Weekend guests enjoyed rooms with sunken marble tubs and fireplaces. The hacienda was quite self-sufficient, with its own water supply, sewage system, an 11,000-gallon fuel storage tank, machine shops, a dairy, orchards, vineyards, vegetable gardens, and a working ranch with beef and dairy cows, poultry, hogs, pheasant, duck, and geese.

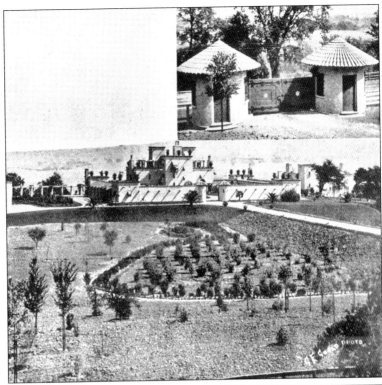

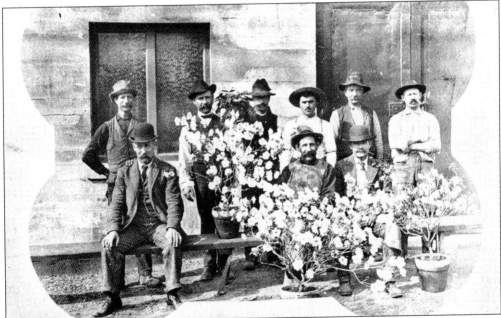

The hacienda employed mostly local help. Here, c. 1910, are some of the 20 gardeners that maintained the elaborate landscaping, partially designed by Phoebe's friend and famous botanist, Luther Burbank. Phoebe was known for taking good care of her employees and their families, often providing Christmas presents for their children and money for medical care. Phoebe also had a standing order to feed all hobos.

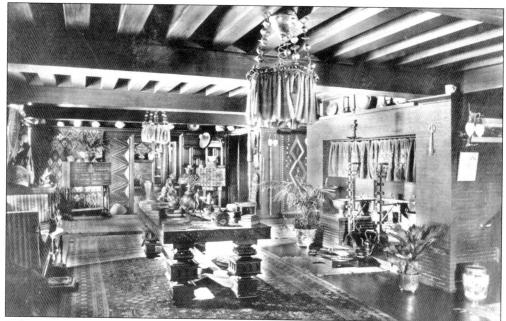

In her many years of world travel, Phoebe developed interests in art and architecture as well as archaeology and anthropology. She accumulated a large collection of art and artifacts that she used to decorate her homes. She financially supported many University of California archaeological expeditions and eventually founded the Robert H. Lowie Museum of Anthropology on the Berkeley campus, which now carries her name. Pictured above is Phoebe's study.

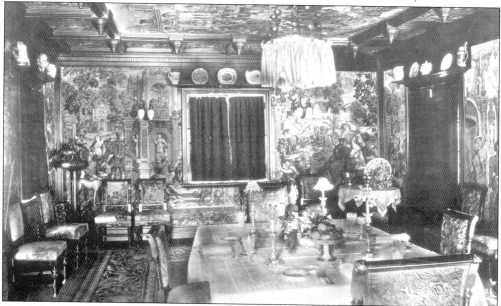

Phoebe's private apartments, located on the second floor of the main building, included her bedroom suite, a study, and this small private dining room. Paintings, tapestries, oriental rugs, bronzes, carved antiques, cabinets and chests, rare clocks, and many native artifacts adorned the rooms. Phoebe also had a concrete warehouse on the premises that stored the overflow of the many antiques and artworks she and William collected.

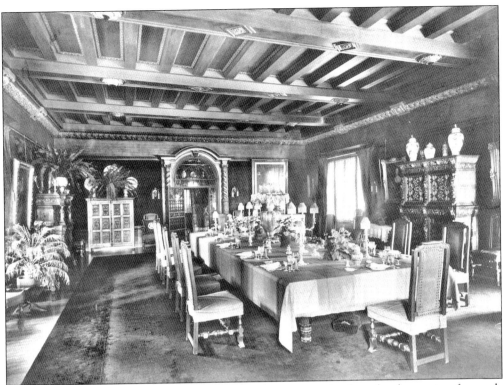

Phoebe's many weekend guests were expected to dress appropriately and to be on time for meals that were served in the main dining room. After the guests assembled, Phoebe descended a staircase that led directly from her private suite to the dining room. Besides mealtime, guests were free to participate in many different activities, including tennis, billiards, or horseback riding.

Elegant but comfortable was the way one publication described the hacienda interior decor. After dinner, Phoebe and her guests moved to the high-ceilinged music room, with its glass skylight, to listen to the piano played by one of the guests. The room could hold 100 people, and many family members and friends were married here. The above photograph was taken in the 1920s, after Phoebe's death.

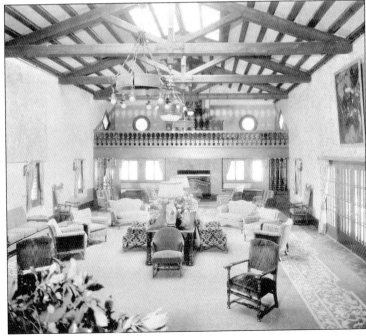

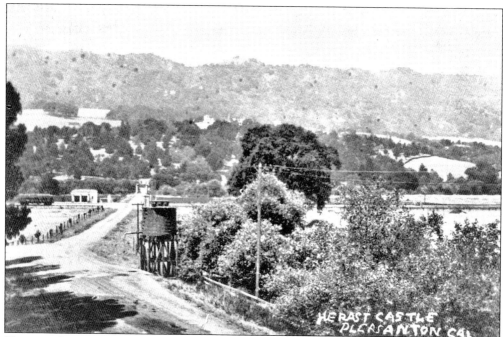

If coming from San Francisco, travel to the hacienda in Phoebe's time meant taking a ferry to Oakland and a train through Niles Canyon. The Western Pacific Railroad built her a private station called Verona. Phoebe also hired trains for special occasions. This c. 1920 photograph shows the station on the valley floor and the hacienda walls above the trees in the upper center of the picture.

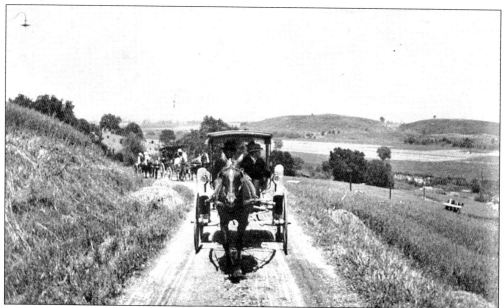

Visitors were greeted at the train station by Phoebe's fleet of carriages, shown here coming up the winding road from the valley below c. 1902. When necessary, she also hired conveyances from local businesses. By 1910, automobiles started to replace the horses, but the early cars often had to be hauled up the steep sections by horses.

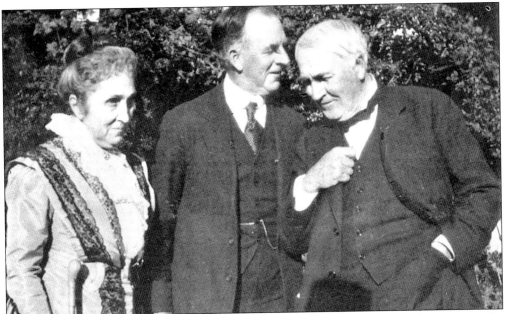

During her tenure in Pleasanton, Phoebe entertained most of the important dignitaries who visited the Bay Area. Royalty, diplomats, presidents, politicians, inventors, and academics were all recipients of her hospitality. Here at the hacienda with Phoebe is William Wallace Campbell, director of the Lick Observatory, which she had helped fund, as well as Thomas Edison.

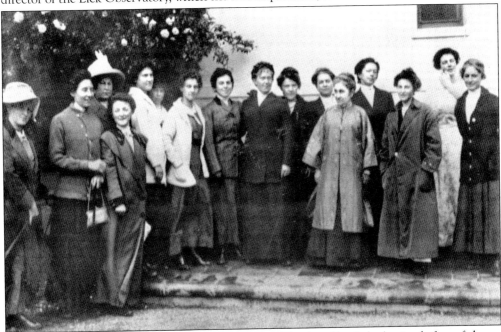

In 1912, in order to raise money for a permanent site, Phoebe offered the hacienda free of charge for the annual YWCA encampment. Three hundred delegates attended the 10-day gathering, and elaborate facilities were erected. The event cost Phoebe $12,000. Asilomar, the permanent camp that Phoebe helped establish, is now a state conference center. Here is Phoebe, fifth from right, with conference attendees.

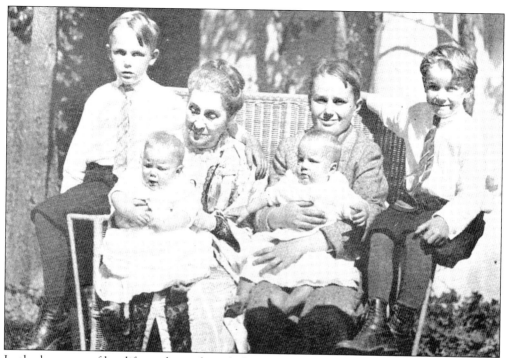

In the last years of her life, nothing pleased Phoebe more than having her grandchildren with her in Pleasanton. The boys spent many summers and holidays at the hacienda. From left to right are William Randolph Jr., born 1908; Phoebe; twins Elbert (later changed to David) and Randolph Apperson (Patty Hearst's father) born 1915; George Randolph, born 1904; and John Randolph, born 1910.

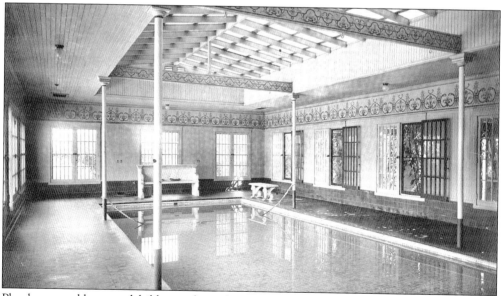

Phoebe wanted her grandchildren to have their own separate space away from others she might be entertaining. In 1909, she had a separate building constructed with a living room, playroom, bedrooms, schoolroom, library, gymnasium, and an indoor swimming pool. The pool, designed by Julia Morgan, was inlaid with green tile in order to give the appearance of the ocean.

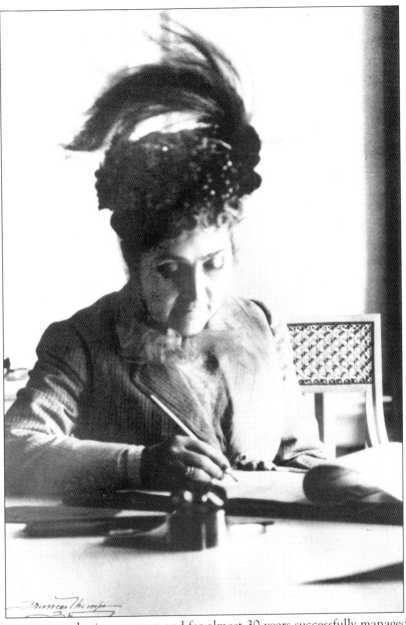

Phoebe was an astute businesswoman and for almost 30 years successfully managed her late husband's mining and real estate empire. However, it was Phoebe's philanthropy that was truly amazing. Focusing primarily on educational activities, she helped start the first free kindergartens in California and contributed money for the construction of schools and libraries all over the country. She also cofounded the first National Congress of Mothers, which later became the modern Parent-Teacher Association. The University of California at Berkeley was particularly blessed to have her as a benefactor. She sponsored an international competition to create a master plan for the campus and funded the construction of many campus buildings, including the George Hearst Mining and Engineering Building. These were just a few of her contributions; in all, she gave over $20 million to charities. Phoebe also never forgot the people of Pleasanton and was an active member of the community during her time here.

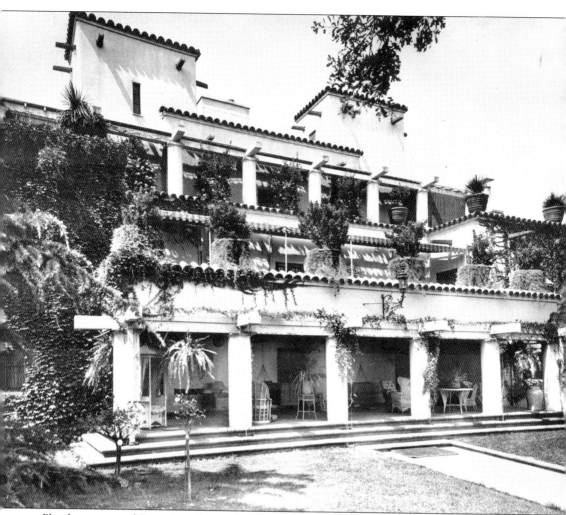

Phoebe contracted Spanish influenza during the epidemic of 1918 and died of complications in her bed at the hacienda on April 13, 1919. Dressed in lavender, her body was laid out for three days in the music room. Private services were held for the family at the hacienda before a public funeral in San Francisco and internment in the family mausoleum at Colma's Cypress Lawn Cemetery. All firsts for a woman, flags were flown at half-mast, some government offices closed, and no classes were held at UC Berkeley. Her estate was valued at $7.5 million after taxes. Bequeathing $500,000 to various friends and family members and $60,000 for scholarships at UC Berkeley, the remainder of the estate went to Will, who at the age of 56 finally controlled his own financial destiny. The Hacienda del Poza de Verona was sold and the proceeds given to her five grandsons. With the help of his mother's favorite architect, Julia Morgan, Will spent the remaining years of his life building his own, much grander version of the Pleasanton hacienda in San Simeon.

# Six
# PROGRESSIVE PLEASANTON

The second phase of the Industrial Revolution, characterized by technological changes, the development of large corporations, and the rise of international markets, plus the completion of the transcontinental railroad, brought many changes to California. In Pleasanton, the ramifications of industrial change were less apparent because of its agricultural economy, but by 1900, inventions like telephones and electricity were impacting the town. The greatest visual change was probably associated with the automobile. On Main Street, there was a slow but steady transition from horse and carriage to the automobile and from livery stables to garages and gas stations.

The Progressive Era, which began in the late 19th century, was a response to the changes brought about by earlier industrial growth. All over the United States, grass-roots action to improve local conditions led to state and nationwide reforms. During this period, reformers focused on beautifying and improving rapidly expanding cities by encouraging the funding of basic public works and the establishment of social services. Even in small towns like Pleasanton, a desire to improve the downtown area and expand existing governmental services took shape. In 1894, Pleasanton incorporated, elected a city council, and began developing a modern urban infrastructure.

At the turn of the century, Pleasanton was prospering and slowly growing, thanks to expanding agricultural production and many, mostly family-run, commercial ventures that provided employment opportunities. Capital for investment became more readily available with the opening of local banks. By 1900, there were more than 40 businesses operating in Pleasanton. Leaders in the business and farming sectors, the city council, and community members all participated in the process of change and improvement.

The Progressive Era also saw the increased involvement of women in public activities. Advocating for the vote and for improvement in the conditions of home, family, and local communities, American women played a major role in the call for reforms at the local, state, and national levels. The women of Pleasanton were no exception; they spearheaded many improvements in the town, including the call for proper sewage and the establishment of a free library.

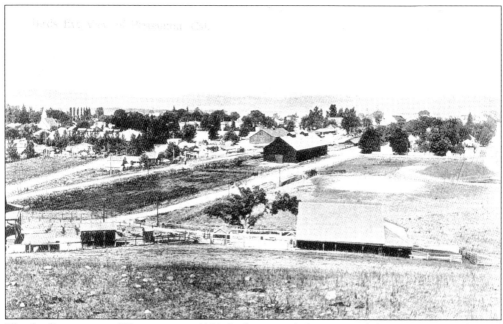

This bird's-eye view of Pleasanton in 1908, looking north from around the intersection of Sunol and Mission Boulevards, shows the distinctive steeple of St. Augustine's Church in the upper left corner and one of the huge barns used to store grain and hay. There is also a baseball diamond in the right portion of the photograph.

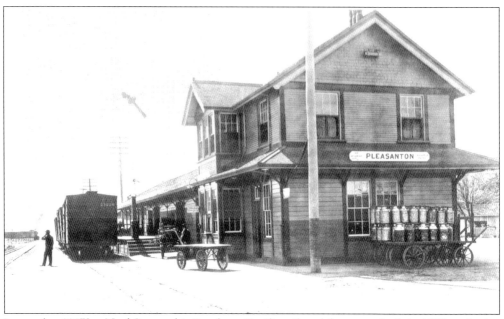

Located at 30 West Neal Street, this Southern Pacific railroad depot was built in 1895, replacing the original structure. During the early years of the 20th century, the train was still a major mode of transportation around the Bay Area for both commuting and pleasure. The depot closed in 1958, but the building was restored in 1988 and now houses modern offices.

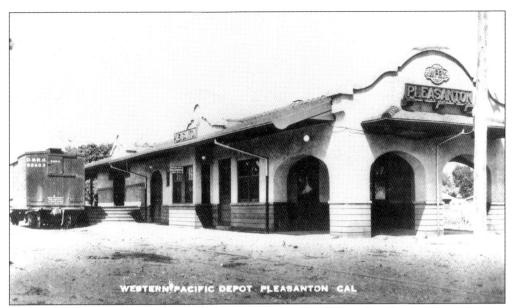

The Western Pacific Railroad came to Pleasanton in 1910 and located its depot on Rose Avenue. Pleasanton was now flanked by two competing railroads. A newspaper editorial at the time expressed concern about Pleasanton's high price of real estate as people from the bay, aided by frequent rail connections, moved to Pleasanton.

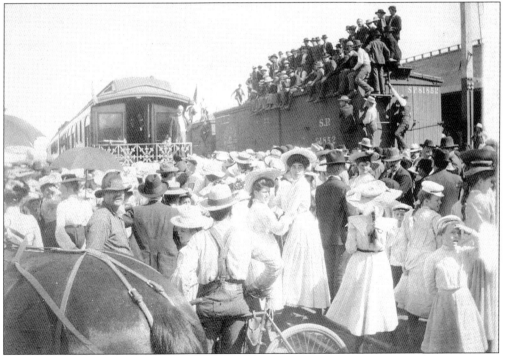

The people of Pleasanton flocked to the railroad station to greet Pres. William McKinley in 1901. McKinley stopped in Pleasanton at the invitation of Phoebe Hearst. Little did anyone know that the president would be killed by an assassin a few months later. McKinley Park, Pleasanton's first official city park, was named in his honor.

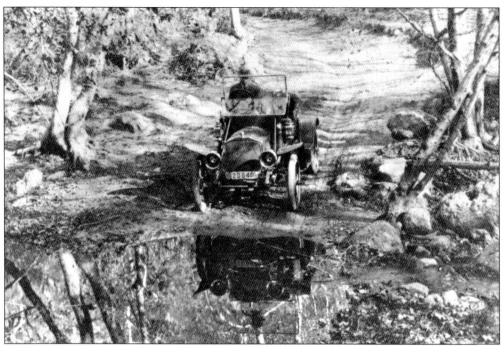

This unknown driver and his Model T Ford attempt to navigate one of Pleasanton's rural roads in the early years of the century. Cars preceded the building of paved roads. This road could be either Foothill Road or Sunol Boulevard.

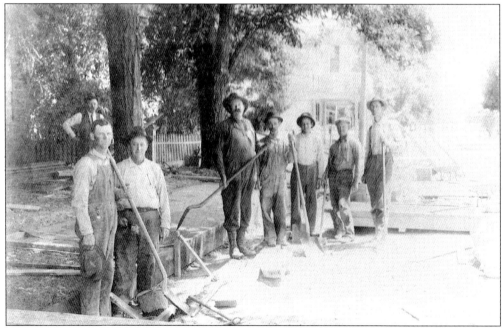

In 1895, Pleasanton began its downtown improvements by approving specifications for streets and curbs. The curbs were made of redwood plank and held together with 50-penny nails. This early 1900s photograph shows Ed Harold and his gang doing the work. Main Street was eventually designated a county road and became eligible for paving funds in 1923.

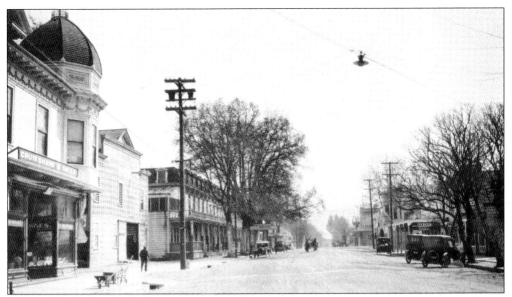

This view, looking south down Main Street, shows the Cruikshank and Kolln Hardware Store, the Wells Fashion Livery Stable, and the Rose Hotel. This 1910 photograph also demonstrates the transition that was happening all across the country as the primary mode of transportation changed from the horse and carriage to the automobile. The livery stable eventually closed in 1937.

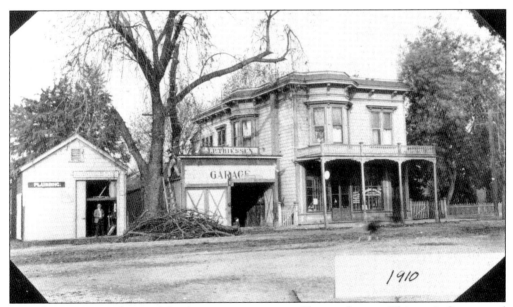

J. P. Thiessen opened one of the first garages in town. Shown above is Thiessen's Garage and Cyclery on Main Street, c. 1910. Thiessen owned the 71st automobile registered in the state and was often hired by Phoebe Hearst to take visitors up the hill. Service stations and garages started to replace livery stables and harness shops by the 1920s.

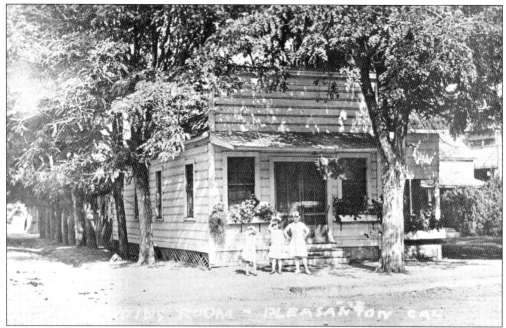

Founded in 1908, the Women's Improvement Club of Pleasanton immediately started planning projects to improve the town. In 1909, the women planted trees on Main Street and, in 1910, established this free reading room. Numerous fund-raising activities were undertaken and, by 1910, the group counted 63 members. A regular anonymous donor was Phoebe Hearst.

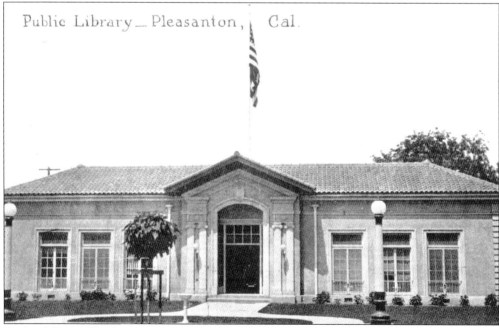

On land donated by the Women's Improvement Club, the first city hall was completed in 1915 at 603 Main Street. In exchange for the land, the city agreed to lease the women's club three rooms in the building for a library, club room, and a reading room for 49 years at $1 per year. The police department also occupied the building.

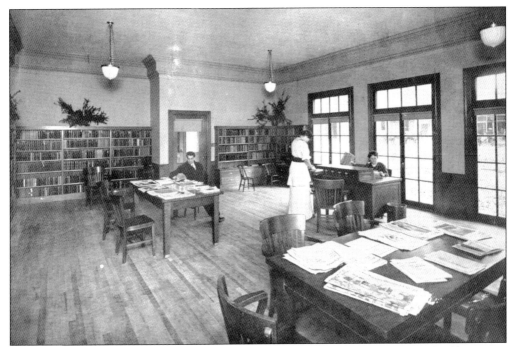

Pictured in 1918 is the new public library located in city hall. The furniture in the library was donated by Phoebe Hearst. Some of the Pleasanton women involved in making the library a reality included Tiller Graham, Bessie Wells, Eleanor Smallwood, Louise Walker, and Mae Pickard.

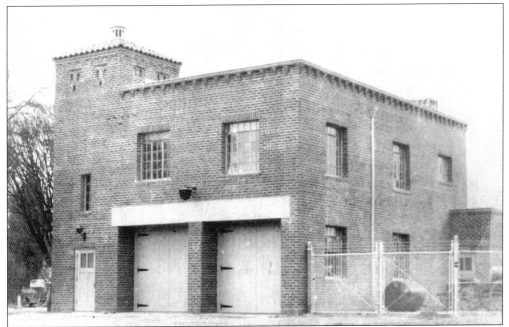

Initially organized in 1888 as a volunteer fire unit with 20 men in three companies, Pleasanton's official fire department was not established until 1901. The first firehouse, located on Railroad Avenue, had a wooden tower with a bell and a small shed for equipment, but it burned down in 1927. Using bricks from the Remillard Brick Company, the city built this new firehouse in 1929.

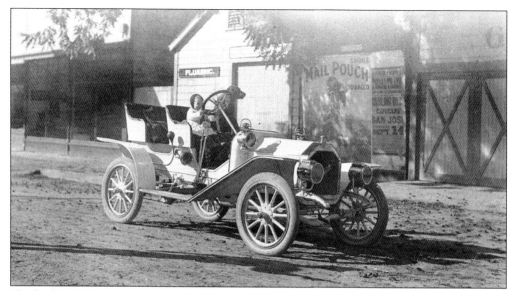

Elizabeth Downing is the little girl driving Bruce Pickard's car, and the passenger seems to be happily along for the ride. This 1920s picture was either taken for fun or possibly while preparing for a parade.

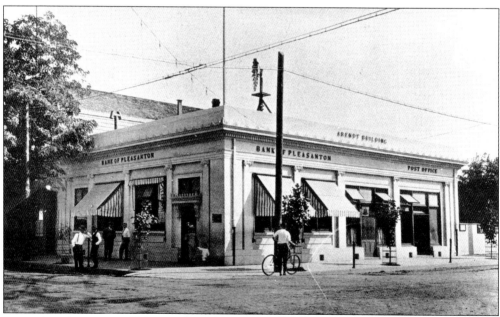

Located at the corner of Main and Neal Streets and built by the Arendt family in 1912, this structure shows the changing architectural styles impacting Pleasanton. By 1923, it was the Bank of Pleasanton, the post office, and the city's telephone exchange. Eventually a branch of the Bank of Italy, which later became the Bank of America, was located here.

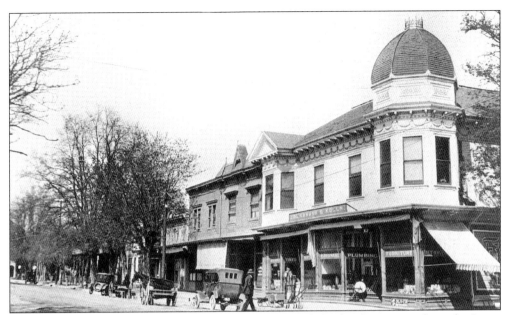

In 1905, James Cruikshank and Herman Kolln purchased this hardware store from the Lewis Brothers. This photograph was taken in 1915. In 1933, Kolln became sole owner. Kolln Hardware represented one of the many long-term, family-run businesses in Pleasanton. The hardware store remained in operation until 2004.

Although times were changing, home deliveries by local businesses continued in Pleasanton well into the 20th century. In 1907, there was a small Chinatown at the north end of Main Street. Chinese peddlers also went door-to-door, making deliveries by carrying their goods in baskets, as shown in 1910. In the 1900 census, 132 Chinese people were listed in Murray Township; by 1910, there were only 54 Chinese residents.

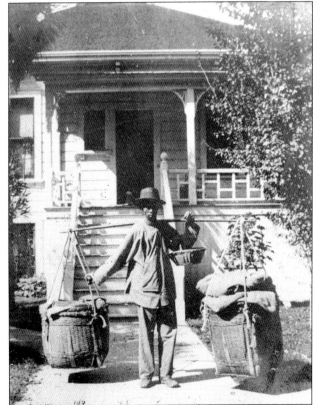

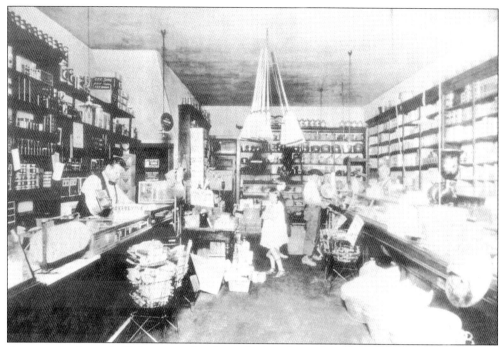

An example of an early-20th-century, family-run food market with living quarters on the second floor, Fiorio's Market was located at 272 Rose Avenue. Originally built in 1903 by Louis Giroud as a general grocery, the Fiorio family bought the store in 1914. Charles Fiorio is on the left behind the counter in this 1920s photograph. Today the building is home to the Valley Plumbing Home Center.

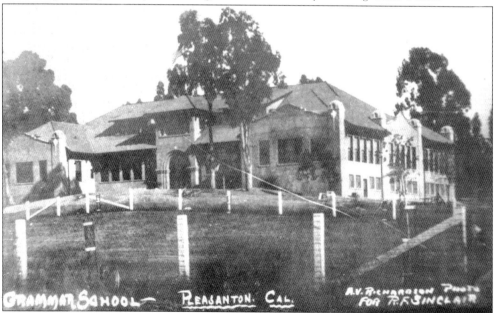

A new Pleasanton Grammar School was built in 1910 after the first school burned. This new $25,000 concrete structure had 10 rooms, hot water heaters, and, for the first time, indoor lavatories, but no electricity. The school, torn down in 1955, served grades one through eight. Alisal Elementary opened in 1956, the first of the "modern" elementary schools.

The first union high school in the valley opened in Livermore in 1891. Pleasanton students had to travel to Livermore by train or horse and buggy if they wanted to continue their education beyond eighth grade. Here are the driver and bus vehicle used by Pleasanton students to get to Livermore in 1917.

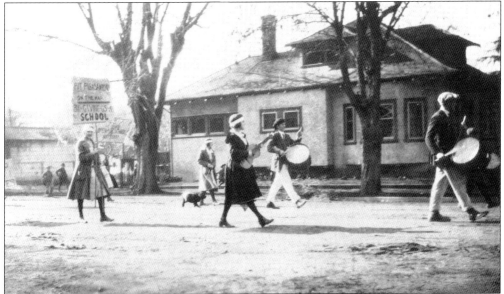

Many high school age youth in Pleasanton did not attend high school because it was considered too expensive and too dangerous to travel to Livermore. In 1922, students marched down Main Street to promote the building of a high school in Pleasanton and to "put Pleasanton on the map," as the sign indicates.

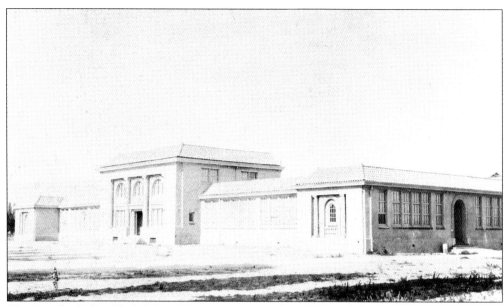

The Amador Valley High School District was created in 1922, and the new high school opened in 1923 on Santa Rita Road, just north of downtown. Originally the district also included schools in the Dublin area.

The famous Pleasanton sign was built in front of city hall in 1932 and served as the city's first neon sign, as well as the police communication system. The sign had flashing lights and a horn that could alert the chief of police when he was needed. The Pleasanton Women's Improvement Club raised the funds for the sign, while the city paid for the poles.

# Seven
# FUN TIMES

Because of their isolation, rural towns such as Pleasanton had to provide much of their own entertainment. Social organizations that sponsored events and activities increased community cohesion and provided residents with opportunities to socialize. From its earliest days, however, Pleasanton also attracted many other visitors. The Bernal racetrack and the horse-breeding farms brought people from afar, and Pleasanton's hotels catered to this business. Downtown Main Street became the focus of many activities, from parades to holiday festivities.

Municipal bands and sports teams were established before the turn of the 20th century. By 1923, however, Amador High School was providing the town with these organizations. Today both Amador and Foothill High Schools have award-winning marching bands and sports teams.

First opening in 1912, the Alameda County Fair was permanently established in Pleasanton by the 1940s. Fair activities included the showing of livestock, local arts and crafts, industrial activities, antique farm equipment, a carnival, horse racing, and sometimes even an automobile demolition derby. A parade down Main Street still opens the fair's two-week run.

Hotels, restaurants, and saloons provided more opportunities for people to come downtown. Other entertainment venues included dance pavilions and theaters. Pleasanton's picturesque Main Street also attracted early filmmakers, both for the scenery and the climate. Phoebe Hearst's hacienda, sold after her death, became a country club and dude ranch, bringing people to Pleasanton for fun and relaxation.

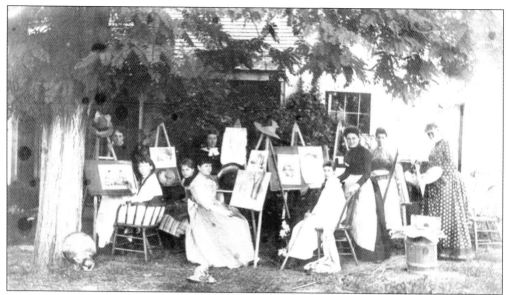

During the Progressive Era, women began to organize and participate in many different public activities, increasing their educational opportunities and organizational skills. Most of these first attempts to move into the public sphere centered on the organization of local improvement societies. Here is the Pleasanton Ladies Art Group c. 1898 practicing their painting skills.

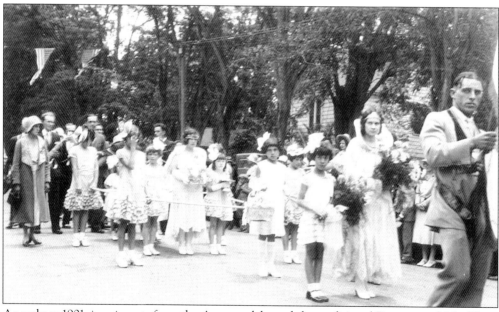

As early as 1901, immigrants from the Azores celebrated the traditional Portuguese Holy Ghost Festival on the weekend of Pentecost Sunday. The 1931 Holy Ghost Festival included a parade down Main Street, shown above, the crowning of a queen, fireworks, a dinner, a dance, and church ceremonies.

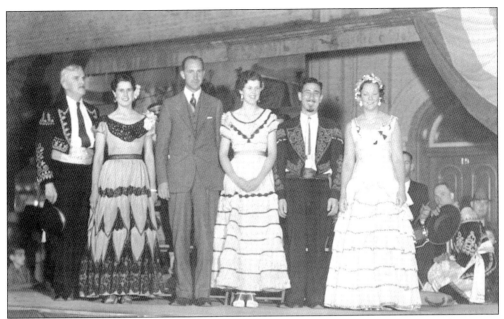

From 1935 to 1938, Pleasanton held an annual two-day event, known as Fiesta Del Vino, to promote the newly rejuvenated valley wine industry. Activities included daily parades, a wine exhibit, a carnival, sporting events, and nightly dances. The girl who sold the most tickets to the event was crowned queen. From left to right are maids Hazel Mendoza and Marie Pereira and queen Geraldine Ratti.

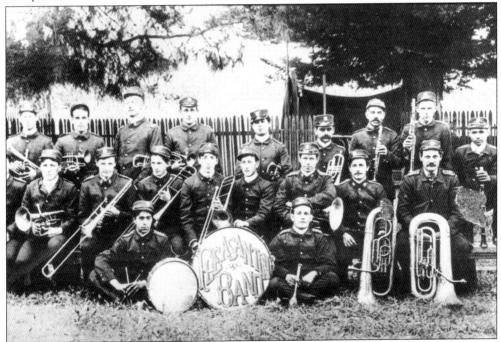

Pleasanton residents organized a municipal band in the late 1800s. Here is the band around 1901. Prominent men from the community participated. A bandstand in Lions Wayside Park at First and Neal Streets is now home to Pleasanton's Friday-night Concerts in the Park.

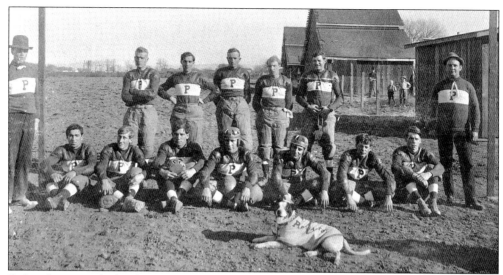

Before there were high school football teams, municipal teams played neighboring towns. Above is Pleasanton's football team *c.* 1908. From left to right are (first row) coach Joe Secada, A. Rosa, A. Abbott, ? Turner, Percy Madsen, ? Allen, ? Frost, ? Worth, and coach Peter Madsen; (second row) ? Davis, James George, Guy Stickler, ? Richter, and ? Davis. Fido is the mascot.

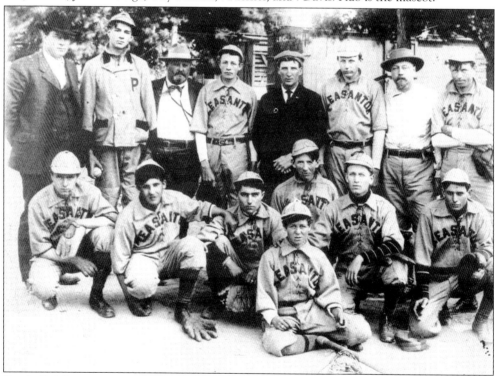

Baseball clubs were organized as early as 1858 in California, and Pleasanton had a team by 1898. Pleasanton's baseball team *c.* 1908 included, from left to right, (front row) Clinton Keeler, Louis Diavila, James George, Jack Murphy, unidentified, Elwood Walters, and Edward Neal; (back row) Lee Wells, Myron Harris, Captain Griffith, Guy Stickler, Joseph Snarey, Grover Bryant, Dr. McConnell, and Charles Rathbone.

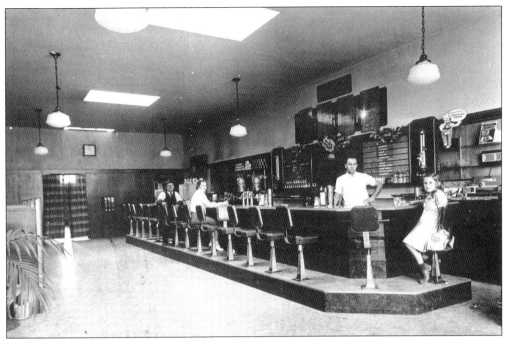

From the 1930s to the 1950s, the Georgis family operated the Creamery, an ice-cream parlor on Main Street. Enjoying themselves left to right are Anton Georgis, Betty Arendt, Jim Georgis, and Marguerite Passeggi.

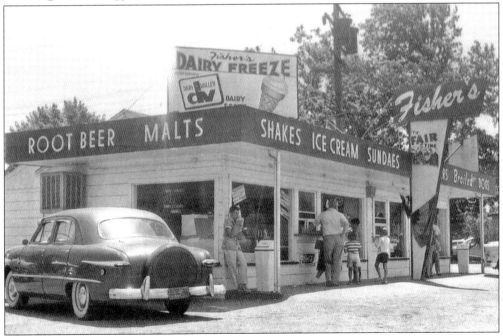

By the 1950s, cruising Main Street was a popular pastime with local teenagers. Fisher's Dairy Freeze, located at the corner of Santa Rita Road and Vervias Street, became a favorite hangout. Teens would drive from Fisher's on the north end of Main Street to the south end of town, turn around, and drive back to the drive-in.

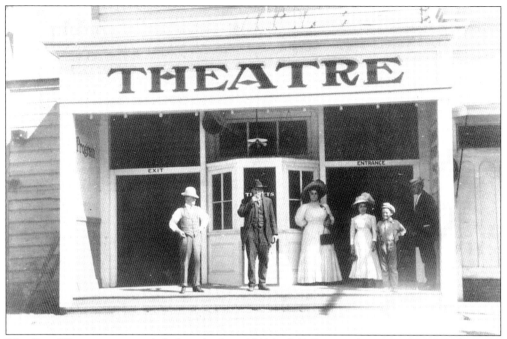

The Gem Theatre was a nickelodeon built in 1910 by J. P. Rosa at 511 Main Street. Admission price was 10¢ to 20¢ for a matinee. It appears from this 1912 photograph that people dressed up to go to the theater. The building became the Lincoln Theater in 1917. Remodeled, it is now the Pastime pool hall.

Constructed in the 1920s and called the New Lincoln Theater by its owner, Charles Chicazolla, this structure became the Roxy Theater in the 1940s. Movies changed two or three times a week, and on Sundays, a 15-minute adventure serial film with a continuing story from week to week was shown. Movie Tone News was a source of pictorial news, especially during World War II.

Born Gladys Smith, actress Mary Pickford began her acting career on Broadway before switching to the new medium of films in 1909. Utilizing her expressive face, she lit up the screen in the silent film era and, along with director D. W. Griffith, pioneered early film acting techniques. One of America's first movie stars, she was known as "America's Sweetheart."

From 1910 to 1916 Essanay Studios operated in Niles (present-day Fremont), shooting many westerns in Niles Canyon. Members of the film crew and famous actors often stayed in Pleasanton. In 1917, Mary Pickford came to town to film *Rebecca of Sunnybrook Farm*. Main Street and other local streets were turned into instant movie sets.

Scenes were shot in various locations in and around Pleasanton, including the Baldwin and Busch ranches. Many local residents, including Marjory Dall, Catherine Smallwood, Gladys Wells, and Eleanor Martin, acted as extras or got bit parts in the film.

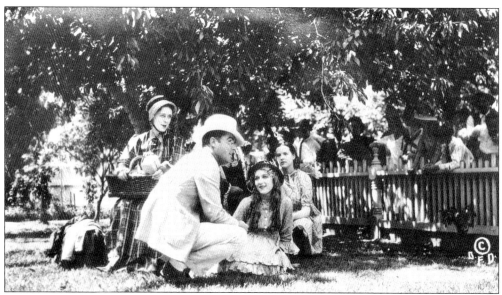

Mary was 24 years old when she filmed *Rebecca*, but she often still played young teenage girls. Pickford reportedly stayed at the Jerome Arendt home (built in 1888), now the Blue Agave restaurant on Main Street. One of the last movies shot in Pleasanton was *It Ain't Hay* with Abbott and Costello in 1941.

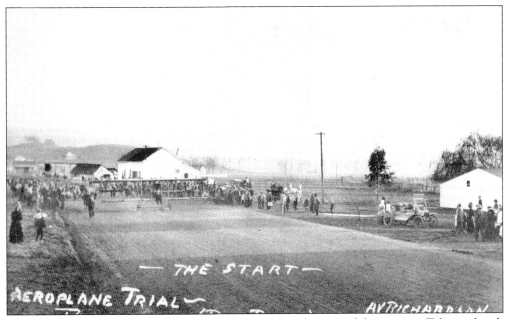

Automobiles and airplanes brought many changes after the turn of the century. Taking a break from horse racing, an airplane trial took place at the racetrack on December 15, 1910.

Organized by the Alameda County Agricultural Association, the first fairs in Alameda County were held in Oakland and Hayward. In 1912, the Alameda County Fair Association was formed in Pleasanton and stock certificates were issued, such as the one issued to Henry Mohr. The first fairs lasted three days and attracted thousands, many arriving by train from other parts of the Bay Area.

Track owner Roger MacKenzie offered his facilities to the association as long as the fair continued, but all improvements belonged to him if the fair stopped. This 1912 photograph shows the grounds and exhibition buildings. MacKenzie laid out a lawn and a palm-lined entryway. Phoebe Hearst's ranch superintendent managed the exhibitions, and she lent her gardeners to help with landscaping.

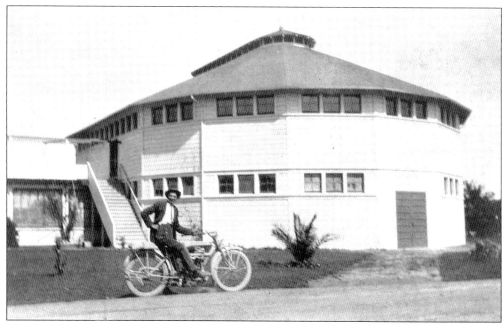

Here in front of one of the two exhibit buildings constructed for the fair is John Schneider on his motorcycle in 1914. Fair activities included band concerts, horse racing, other contests, and exhibitions. Held annually from 1912 to 1914, the fair was halted because of the 1915 Panama-Pacific International Exposition and the coming of World War I.

In 1933, pari-mutuel betting was legalized and included a tax that subsidized fairs and promoted Thoroughbred racing. Horses began training again at the Pleasanton track, including Seabiscuit in 1936. The racetrack remained privately owned until the county purchased it from the MacKenzie heirs in 1941. The grandstand was expanded in 1952.

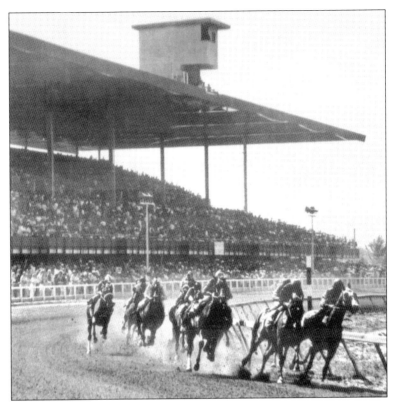

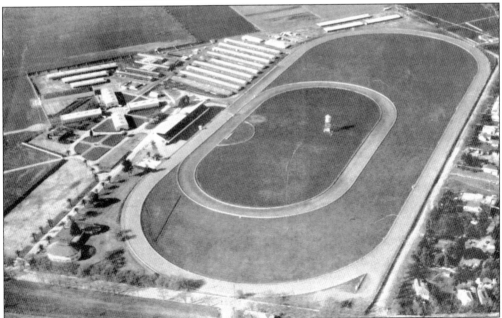

During the down years between 1916 and 1932, the fair buildings deteriorated and the grandstand burned down. In 1939, local businessmen helped reorganize and fund the fair, and community volunteers built a new grandstand and worked the event. This 1950s aerial view shows the racetrack, horse barns, and fairgrounds. The 1912 exhibition buildings are in the lower left corner.

The fair was not held during World War II. Instead, the grandstand was used as a lookout point to watch for enemy aircraft, and the living quarters under the grandstand were used to house Mexican laborers who harvested the wartime crops. The fair was brought back in 1945. Besides other fair activities, the demolition derby, such as this 1950s event, was very popular.

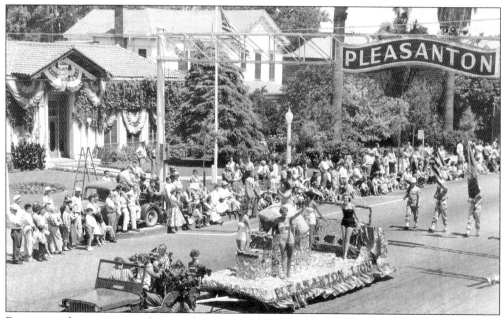

Every year, downtown was decorated and a parade was held to kick off the annual county fair. Above is the Pleasanton Lions Club float c. 1950.

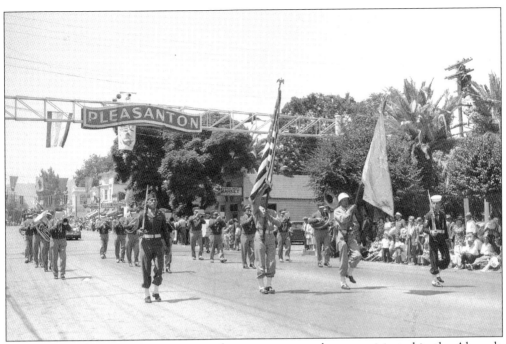

Marching bands, civic organizations, and veterans groups always participated in the Alameda County Fair Parade down Main Street. The above picture was taken in 1947.

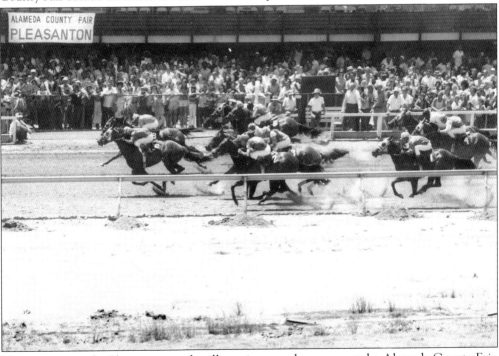

Horse racing on the Pleasanton track still continues each summer at the Alameda County Fair. Harness racing ended in 1968, and the inner track was removed. By the mid-1970s, a nine-hole golf course was added, and in 1991, a satellite wagering facility opened. The fairgrounds are used for many different events throughout the year.

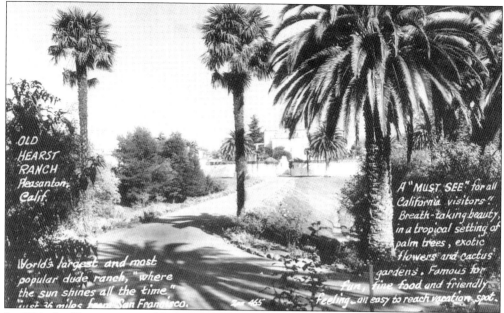

In 1924, the Hearst estate sold Phoebe's hacienda and 510 acres to a group who turned it into Castlewood Country Club. An 18-hole golf course and a swimming pool were added. The Depression years saw a decline in membership and, in 1940, the owners sold the property to John Marshall. Marshall upgraded and refurbished the run-down facilities and opened a dude ranch, as advertised in the above postcard.

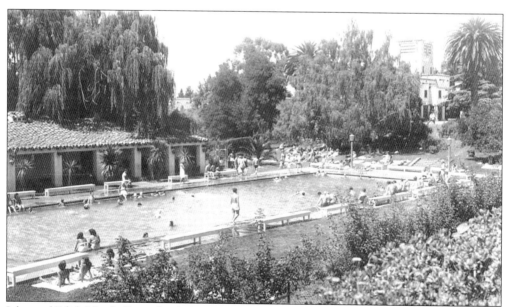

John and Edith Marshall ran the dude ranch from 1940 to 1952. Guests came from all over to stay at the "Old Hearst Ranch." This view of the crowded pool on a hot summer day was taken in the 1940s. KSFO radio held "Dude Ranch Breakfast" shows on location on Sunday mornings.

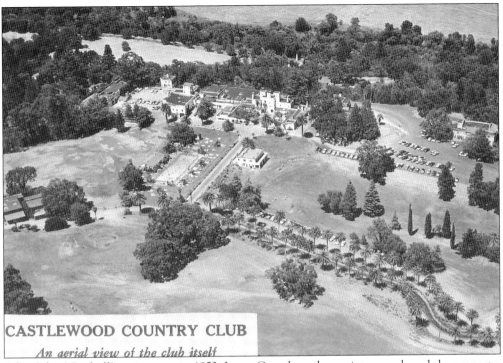

**CASTLEWOOD COUNTRY CLUB**
*An aerial view of the club itself*

After John Marshall's retirement in 1952, Larry Curtola and associates purchased the property. His group converted the resort into the new Castlewood Country Club. The original golf course was altered and a new 18-hole course added east of Foothill Road. For the first time, home lots adjacent to the golf course were sold.

In 1961, club members exercised their option to purchase the property from Curtola for $1,250,000. Unfortunately an electrical fire broke out in August 1969, destroying the original buildings of the hacienda. Fire trucks from all over the valley responded to the three-alarm fire, and water from the pool was used to quench the flames but to no avail.

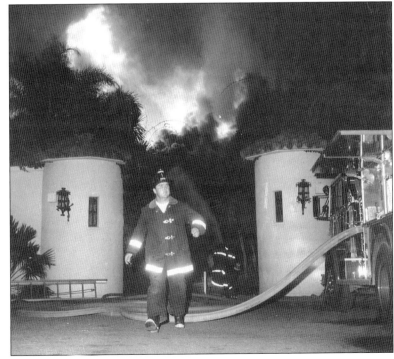

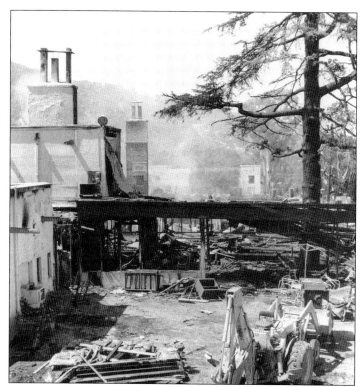

By the next morning, not much was left of the once grand Hacienda del Pozo de Verona. For the city of Pleasanton, a part of its history was gone forever and residents would no longer be able to gaze up at Phoebe's castle.

Rebuilt after the fire, the country club continues to operate as a private enterprise. This aerial view of the facilities was taken in June 1974.

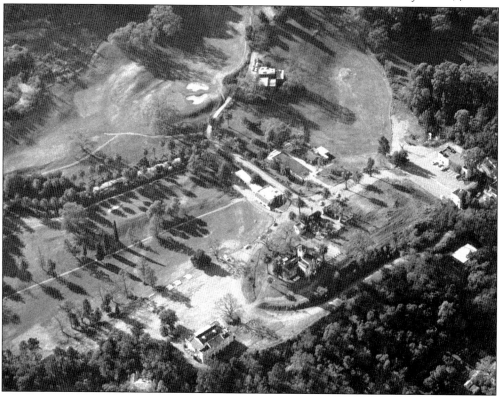

# Eight
# A Changing World

Through the 1930s and 1940s, Pleasanton's population remained around 1,200 people and its economy continued to be dominated by agriculture. Apricots, tomatoes, and walnuts, in addition to grain and hay, increased in value. When the Jackson and Perkins Company established growing and wholesaling operations here in 1939, Pleasanton also became a leading center for rose hybridization.

World and national events, however, soon led to more rapid changes. During World War II, Pleasanton's population doubled, primarily because of the soldiers and their families who came to the valley military bases established for training and deployment. After the war, the valley became a center for military research and development, bringing more people to the valley. By the 1960s, Pleasanton's population had increased to 4,203 residents.

In the 1940s, U.S. Route 50 was widened, rerouted, and connected with a four-lane road through the Altamont Pass. The Federal Highway Act of 1956 provided crucial highway funding and played a pivotal role in changing the demographics and economy of the Amador–Livermore Valley. The transition from two-lane highways to four-lane interstates enabled residents of the valley to access job centers in the East Bay, while less expensive home prices in Pleasanton attracted new residents.

By the 1960s, taxes on agricultural land had increased; at the same time, the land was also becoming more attractive to urban developers. Farmers struggled to hold on to their farms but eventually sold out. Farmland was replaced by suburban homes, shopping centers, and business parks. Pleasanton's ranching and farming past slowly disappeared.

By the 1990s, Pleasanton had become one of the new suburban job centers springing up around the Bay Area. Technology companies and branch offices of major corporations began relocating to the city. Companies moved from San Francisco and the East Bay to the valley, attracting workers who now lived away from the earlier business centers. BART came to the valley in the early years of the new century, further opening up commute possibilities. In just over 40 years, Pleasanton's population reached over 70,000.

In 1940, hay was still a viable crop in the valley. Shown here is Hans Bonde, working a Junior Monarch five-wire hay press. Three generations of the Bonde family worked as commercial hay balers in the valley. The next 30 years saw farmland slowly give way to housing tracts. Every year, a large exhibit of antique farm machinery at the Alameda County Fair showcases the valley's past.

From 1938 into the 1960s, roses of every variety were grown in both Pleasanton and Livermore. Jackson and Perkins was the largest producer, but there were seven other growers leasing land from local farmers. By the mid-1950s, there were 12 million rose plants in the valley. One by one, fire, disease, and higher property taxes forced companies to leave. The last rose company left Pleasanton in the 1990s.

The Veteran's Memorial Hall, dedicated to the American veterans of foreign wars and erected in response to World War I, was completed in 1933. Only eight years later, it served as the USO center for Camp Parks, which was built just north of Pleasanton during World War II.

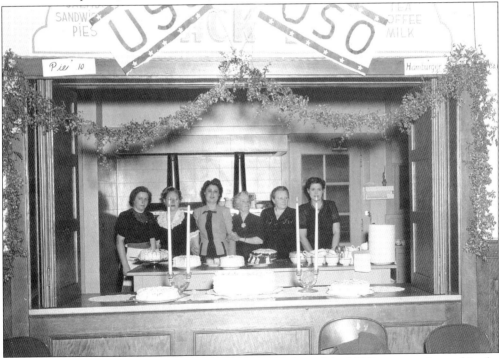

Doing their patriotic duty are some of the volunteer ladies of the USO canteen, located in the Veterans Memorial Hall on Main Street. During the war, Pleasanton's downtown became a major source of fun and relaxation for off-duty service personnel. In addition, several temporary housing villages were built in Pleasanton for military families.

Cold war nuclear weapons research and development facilities also brought many new residents to the valley. The nation's first licensed commercial nuclear reactor, the Vallecitos Nuclear Center, was built just south of Pleasanton by General Electric in 1956. Scientists and other professionals who came to work at these centers also influenced the changing demographics of the local population. The plant shut down in 1977 because of a nearby earthquake fault.

All Americans were impacted by the threat of the nuclear arms race with the Soviet Union that lasted until 1991. In the 1950s, Pleasanton schoolchildren practiced air-raid drills by ducking under their desks.

Although the old Pleasanton lagoon had been drained early in the century, during a heavy rain year, the area still flooded. Pictured above in 1955 is the east side of Hopyard Road, where the sports park is now located. This flood delayed the building of new homes in the area, but eventually, new drainage systems allowed business and home development.

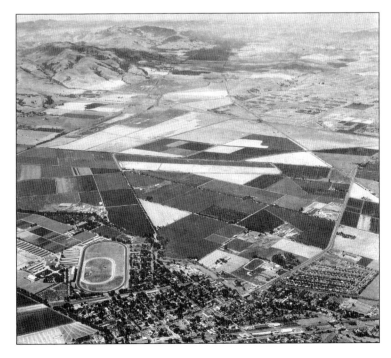

This 1965 aerial view of Amador Valley shows Pleasanton in the lower portion of the photograph. In the next 30 years, housing developments and businesses would cover the undeveloped fields located north and west of Pleasanton.

Producing sand and gravel for building and paving has been a viable industry in Pleasanton since 1923. Pictured at left c. 1960 are two of Pleasanton's ongoing gravel concerns. Separated by Stanley Boulevard are Rhodes and Jamieson, top, and Pacific Coast Aggregates (PCA), now Lone Star, below.

Henry J. Kaiser began his career in 1923 when he came to Pleasanton to build the road between Pleasanton and Livermore. Kaiser operated two different gravel operations in the valley, including the Radum plant in Pleasanton. Kaiser never forgot his beginnings, locating the Kaiser Center for Technology, seen above, just south of downtown in the 1970s.

Federal money invested in the valley after World War II contributed to major changes. Federal funds for highways provided the necessary transportation infrastructure, which laid the foundation for future growth. This 1960s photograph shows the Interstate 580 and 680 interchange, which gave the valley both north/south and east/west thoroughfares.

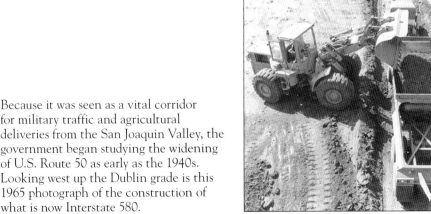

Because it was seen as a vital corridor for military traffic and agricultural deliveries from the San Joaquin Valley, the government began studying the widening of U.S. Route 50 as early as the 1940s. Looking west up the Dublin grade is this 1965 photograph of the construction of what is now Interstate 580.

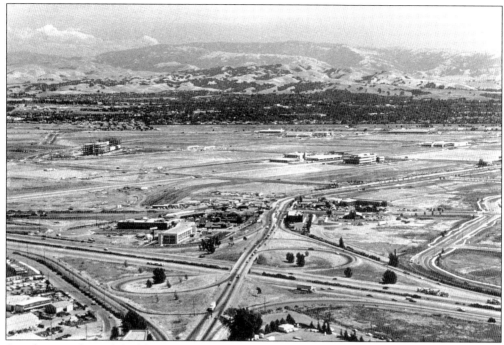

Seen here are the early buildings of the Hacienda Business Park, which in 1982 began development in close cooperation with city planners. Over 8 million square feet of office/commercial/industrial space was constructed. In addition, Stoneridge Mall opened west of the business park in the 1980s. Both developments brought huge tax revenues to the city.

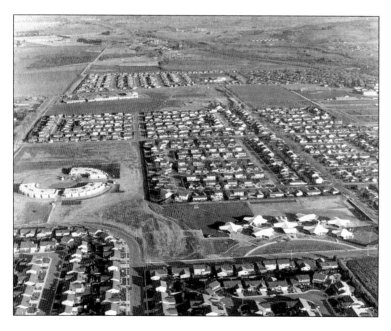

Beginning in the 1950s and continuing throughout the rest of the century, new housing tracts and schools were built on former farm and dairy lands. Looking east, across the former Black farm and Orloff dairy lands, are the Morrison housing tract, Walnut Grove Elementary School in the lower right corner, and Harvest Park Middle School in the circular buildings to the left. Both schools were built in 1968.

# Nine
# THEN AND NOW

Most towns have their historic landmarks. While preserving the past is usually the domain of local historical societies, smart city councils and chambers of commerce have also understood the importance of using a community's past to help maintain its identity. Pleasanton has been fortunate that past officials supported the effort to retain a core stock of historic structures, especially in and around downtown. From the famous Pleasanton sign over Main Street to the still-entertaining Pleasanton Hotel, the city can be proud of its preservation efforts.

Pleasanton has been able to keep the historic character of its Main Street for several reasons. During the 1950s-to-1970s era of major redevelopment in cities across America, many downtown areas were radically altered and older buildings were replaced by modern architectural structures. Because of its location off the beaten path and because of the vision of a committed group of city planners, Pleasanton managed to avoid this trend. Secondly, in 1963, members of the Pleasanton community recognized the need to document and preserve Pleasanton's history, forming the Amador–Livermore Valley Historical Society to educate and advocate for preservation.

Even more importantly, many of Pleasanton's historic structures still stand because they have continued to be used in viable ways. Restoration, rehabilitation, and reconstruction efforts have all contributed to the maintenance of Pleasanton's historical integrity. One example is the Kolln Hardware building, famous for its landmark Queen Anne turret. The hardware store had various owners and names, but it remained a retail establishment for over a hundred years. A $2-million renovation in 2007, bringing the structure up to modern building codes, will ensure a continuing long life for this historic building. In addition, in order to maintain the historic flavor of downtown, even new buildings constructed on Main Street are built in compatible architectural styles, including the newest Rose Hotel.

Thousands of people come to downtown Pleasanton to enjoy the ambiance of its historic look and feel and to experience the sense of community that is embedded in its story. For visitors wishing to know more about Pleasanton's story, the Museum on Main Street offers walking tours and showcases Pleasanton's history in a permanent exhibit. Thanks to both good planning and good luck, the past is present in Pleasanton.

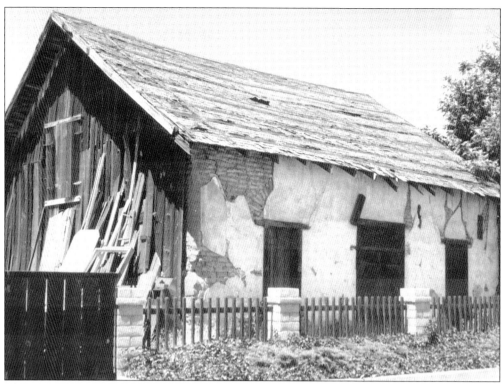

This 1981 photograph of the Kottinger adobe barn on Ray Street shows how the adobe looked 130 years after its construction but before it was restored and turned into an antique shop.

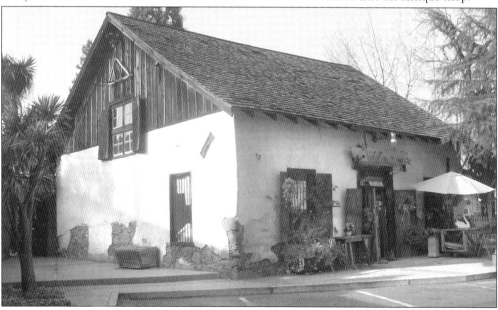

Here is the Kottinger Barn in 2007, in its most recent incarnation as a gift shop. Its historic legacy as Pleasanton's oldest building can be seen in the exposed adobe bricks in the lower left side of the picture. It is the only building in Pleasanton on the National Register of Historic Places. (Courtesy Samantha Wainwright.)

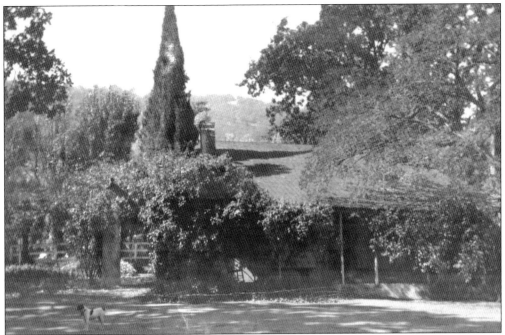

The Alviso Adobe, located at 3465 Old Foothill Road in Pleasanton, is seen as it looked in the 1970s. During this time, it was owned by a Texas corporation that planned to build a Six Flags amusement park. These plans were never realized; the land was eventually purchased by the DeSilva Group, which built the Laguna Oaks housing development below the adobe and donated the adobe property to the City of Pleasanton.

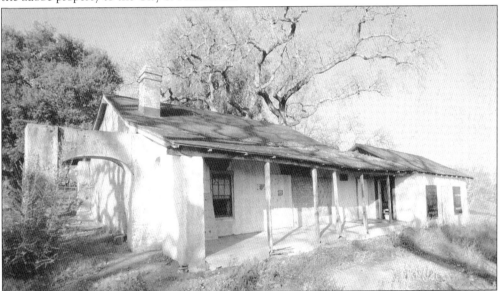

The Alviso Adobe, as it looks in 2007, awaits development as the Alviso Adobe Community Park. Plans include restoring the adobe so that it illustrates both its occupation by the Alvisos and its later role as part of the Meadowlark Dairy. Also located on the property are boulders with Native American cupules (holes in the rocks where Native Americans ground acorns) that evidence its pre-Spanish occupation by native peoples.

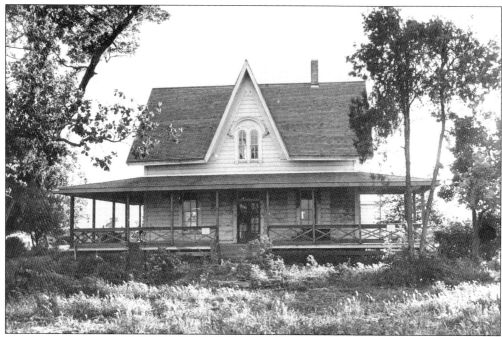

This house was originally built in 1878 as a hunting lodge and weekend retreat for San Franciscan George Atkinson. It was leased by Robert Blacow in 1906 and later purchased by the Trimingham family, who lived in it until 1947. This 1973 photograph shows how the structure looked before it was restored and renamed the Century House.

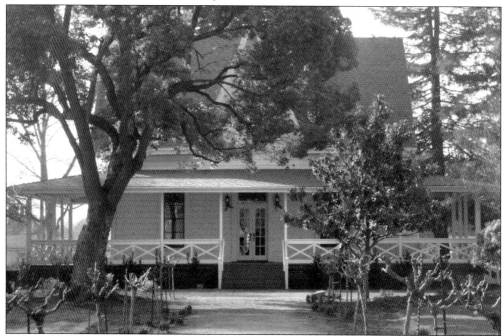

The Century House was restored in the 1970s. Shown in 2007, the Victorian-era cottage is managed by the Pleasanton Parks and Recreation Department, is used for various events, and is available for rental by private individuals and groups. (Courtesy Samantha Wainwright.)

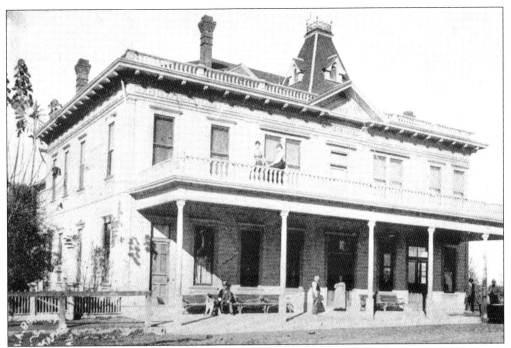

This 1902 photograph shows the rebuilt Farmers Hotel that replaced the original 1864 hotel built by John Kottinger. In 1919, the business was renamed the Riverside Hotel, and in 1934, it became known as the Pleasanton Hotel. Through the years, three different hotels in downtown have been called the Pleasanton Hotel.

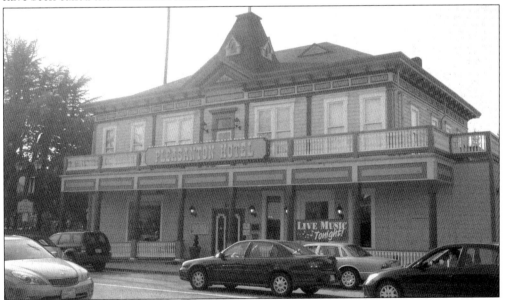

Today the Pleasanton Hotel is a popular restaurant and night spot, with live music on weekends. It is also a popular location for weddings and other celebrations. During the 1960s, it stopped taking overnight guests, and the upstairs rooms were converted to private offices. Name changes, restoration, and remodeling aside, it still looks very much the same as it did in 1902. (Courtesy Samantha Wainwright.)

Pleasanton residential streets in the early part of the 20th century were paved with gravel and had no sidewalks or curbs. Picket fences and mature trees lined the wide avenues. In 1910, when this photograph was taken, the ride along St. John's Street must have been uncomfortable in the horse and buggy seen on the left.

Many of the original trees are now gone from St. John's Street; there are lines painted down the paved road and cars parked on the street in this 2007 photograph. It is not quite the picturesque scene of the early 20th century, but St. John's is still an attractive residential thoroughfare. (Courtesy Samantha Wainwright.)

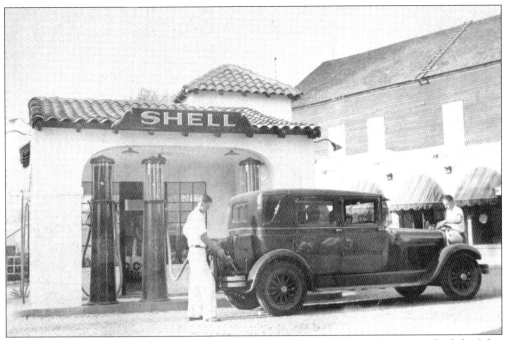

This Shell gas station on the northwest corner of St. Mary and Main Streets was built by John Amaral in 1931 in the Mission Revival style. It is on the site once occupied by Kottinger's Germania/Pleasanton Hotel.

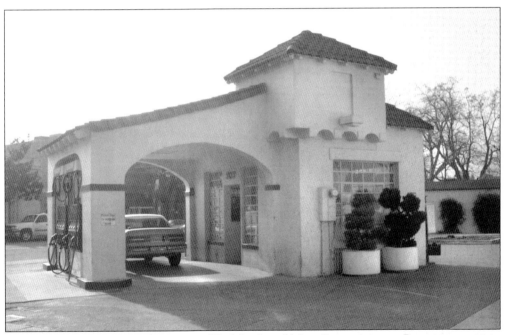

The historic gas station on the corner of St. Mary's and Main Streets is now a Beacon gas station. The pump style and cars have changed, and there is no service attendant to wash the windows and check the oil, but besides a new coat of whitewash, the building is remarkably unchanged. (Courtesy Samantha Wainwright.)

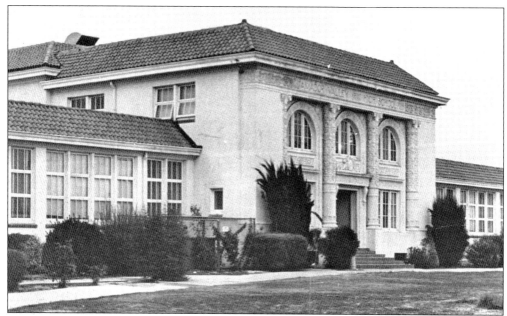

Amador Valley High School (pictured c. 1930) served as the only local high school until the late 1960s. While Dublin High was being constructed in 1968, the students of both Pleasanton and Dublin attended double sessions on the Amador campus. The districts were split in 1988, and Pleasanton schools were consolidated into the Pleasanton Unified School District. Foothill High School opened in 1973, and Village Continuation School opened in 1978.

Much of the original Amador High School building was torn down in 1968 and replaced with newer additions. Through the years, modernization continued, with a new two-story structure added in 2004. The remodeled auditorium, now called the Amador Theatre, is part of the original building. It now serves both the school and the community. (Courtesy Samantha Wainwright.)

Henry Moller started a meatpacking business on Foothill Road in 1914 near today's Stoneridge Mall. For 80 years, the Moller family provided fresh meat for the valley, but by the 1960s, population growth, problems with traffic, and complaints from neighbors made staying in business difficult. This problem is clearly visible in this 1960s photograph, as the Moller family herds cattle up Foothill Road.

Henry Moller died in 1976, and the slaughterhouse closed in the 1980s. The family chose to sell the 200-acre ranch above Foothill Road to developers in the 1990s. All that is left of the once-thriving family business is the name, memorialized by the stone signs leading to the homes now known as the Moller Ranch Estates. (Courtesy Samantha Wainwright.)

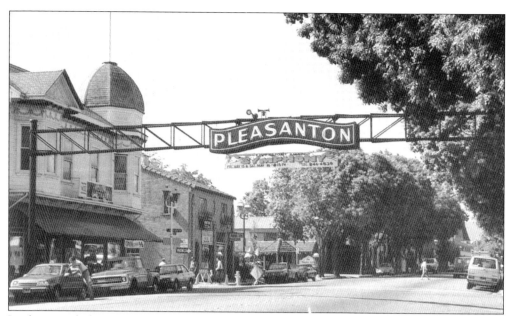

Looking south down Main Street in the 1970s, the famous Pleasanton Sign, one of the few town gateway signs remaining in California, is still used to announce upcoming events. Although many of the buildings along Main Street still have the look of the 19th century, most have been remodeled or reconstructed to meet modern building codes and accommodate new uses.

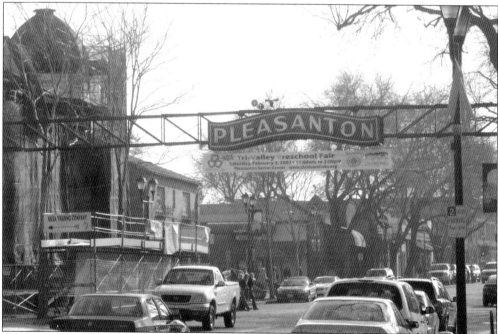

Main Street in 2007 looks remarkably unchanged. It has maintained its commercial viability, adding restaurants and offices through the years. The Kolln Hardware building on the left is undergoing major structural renovation that will maintain its exterior appearance. As a result of this effort, one of Pleasanton's most recognizable landmarks will not be lost, and Pleasanton's historic flavor will continue well into the 21st century. (Courtesy Samantha Wainwright.)

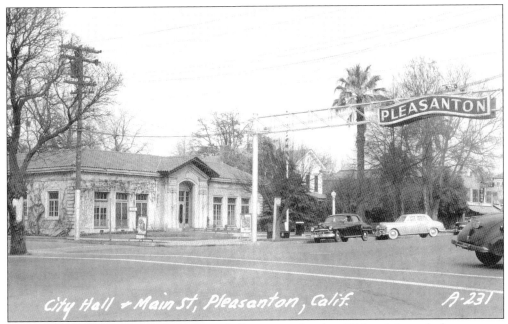

Seen here in the 1950s, Pleasanton's town hall was completed in 1915 and through the years was occupied by various civic offices. By 1984, all the city offices and the police department had moved to new buildings. In 1985, the Amador–Livermore Valley Historical Society leased the building and, with the help of volunteers, restored it to house the new museum and archives.

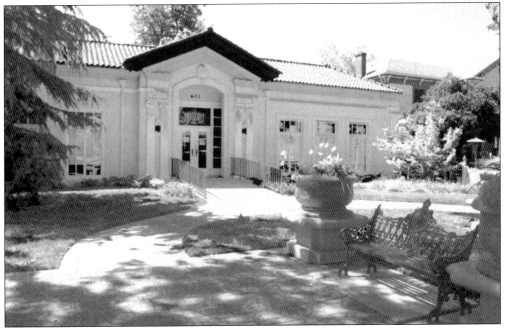

The Amador–Livermore Valley Historical Society's occupation of the old city hall has helped keep history alive in downtown Pleasanton. Now called the Museum on Main Street, the society offers historical education and historically themed entertainment to both community residents and visitors, as well as operating a research center for local history. (Courtesy Jim Allen.)

## Across America, People are Discovering Something Wonderful. Their Heritage.

Arcadia Publishing is the leading local history publisher in the United States. With more than 3,000 titles in print and hundreds of new titles released every year, Arcadia has extensive specialized experience chronicling the history of communities and celebrating America's hidden stories, bringing to life the people, places, and events from the past. To discover the history of other communities across the nation, please visit:

## www.arcadiapublishing.com

Customized search tools allow you to find regional history books about the town where you grew up, the cities where your friends and family live, the town where your parents met, or even that retirement spot you've been dreaming about.